POSTCARD HISTORY SERIES

# The Thousand Islands

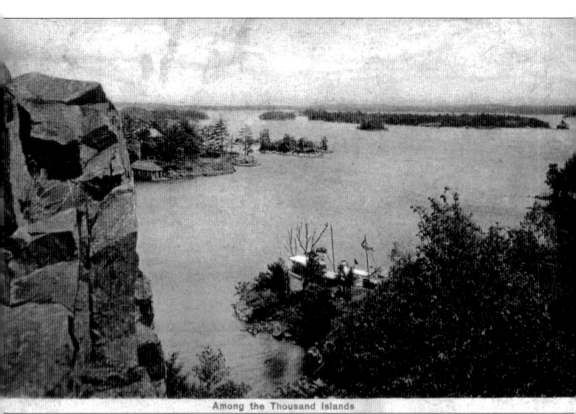

Among the Thousand Islands

The Thousand Islands as they are seen today were formed after the last ice age some 10,000 years ago, barely a moment in geologic time. Retreating glaciers scraped away an overlayer of accumulated softer rock to expose Precambrian bedrock over a billion years old. Visible above the river's surface are outcroppings, crags, and cliffs in the granite that forms the islands—some of the oldest rock on the earth. Underwater, an equally impressive landscape exists. Chasms in the river reach over 250 feet in spots, and sheer, submerged cliffs over 90 feet deep can be found in several locations. (Antique Boat Museum.)

*On the front cover:* Remains of the massive timber cribs that once supported the main dock on the northeast corner of Round Island lurk just below the surface today. The dock served islanders and the magnificent Frontenac Hotel in the island's center. The hotel burned in 1911, and the dock fell into disuse shortly thereafter. (Antique Boat Museum.)

*On the back cover:* Misspelled on the actual postcard, Neh-Mahbin stands on the head of Comfort Island with a commanding view for several miles up the American Narrows to the Thousand Islands Bridge and beyond. (Antique Boat Museum.)

POSTCARD HISTORY SERIES

# The Thousand Islands

*The Antique Boat Museum*

ARCADIA
PUBLISHING

Copyright © 2009 by the Antique Boat Museum
ISBN 978-0-7385-6510-1

Published by Arcadia Publishing
Charleston SC, Chicago IL, Portsmouth NH, San Francisco CA

Printed in the United States of America

Library of Congress Control Number: 2008942673

For all general information contact Arcadia Publishing at:
Telephone 843-853-2070
Fax 843-853-0044
E-mail sales@arcadiapublishing.com
For customer service and orders:
Toll-Free 1-888-313-2665

Visit us on the Internet at www.arcadiapublishing.com

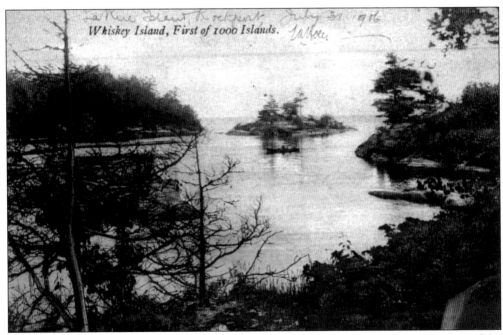

Whiskey Island, First of 1000 Islands.

There are four Whiskey Islands in the upper St. Lawrence River, and none are the first of the Thousand Islands. Depending on one's sailing direction, the first islands are either McNair Island downriver from Brockville or sprawling Wolfe Island at the head of the river between Cape Vincent, New York, and Kingston, Ontario. The Whiskey Island pictured here lies off the lower end of Cedar Island downriver from Kingston. (Antique Boat Museum.)

# CONTENTS

# ACKNOWLEDGMENTS

At some point in the late 1980s, my maternal grandfather, Bronson A. Quackenbush, gave me his cherished collection of Thousand Islands postcards, hoping I would pick up where his advancing age and declining interest left off. He had amassed the collection over several decades during the latter part of his life. The nearly 3,000 cards were carefully categorized and stored in gray steel catalog boxes.

Some 20 years later and after his death in 1996, the cards remained untouched in a corner of my basement. Fittingly, they are now included in the growing collection of Thousand Islands memorabilia at the Antique Boat Museum in Clayton.

For joining the project to bring the Quackenbush collection to the light of day, my gratitude goes to my coauthors, Windsor Price (a dear friend of my grandfather's and a postcard collector in his own right) and Fred H. Rollins (antique postcard aficionado and professional appraiser). Personal thanks also go to Tony Mollica (Thousand Islands book author, fellow museum trustee, and fact-checker), Leslie Rowland (my supportive wife and first-rate proofreader), Dan Miller (museum curator) and the several unsung volunteers who so carefully committed the collection to the museum's archives. They all helped deliver this book from my basement to reality.

*The Thousand Islands* is dedicated to Bronson: a grandfather, friend, gentleman, trustee, postcard collector, and erstwhile "river rat."

Except as noted, all the images seen here are from the collections of the Antique Boat Museum.

—Frederick H. Hager, March 2009

# INTRODUCTION

When Randy Marshall, a Syracuse antique dealer specializing in books, maps, and other paper memorabilia, contacted me about a postcard collection that needed to be appraised, I was skeptical. He knew that I was the director of the Western New York Postcard Club, had been collecting antique postcards for over 30 years, had just retired as executive director of the Jefferson County Historical Society, and was a professional appraiser of postcards and other antique materials. And he knew very well that, all too often, the postcard collections I appraised were nothing more than a shoe box full of dusty cards that had little historic or monetary value. However, he was excited about this particular collection, and I soon agreed.

The Bronson A. Quackenbush collection of Thousand Islands postcards turned out to be vastly different from the typical shoe box collection. First, Quackenbush was a knowledgeable and discriminating collector. Second, he assembled a uniquely comprehensive collection with many unusual, interesting, and rare cards. Third, the scope of the collection was immense, with nearly 3,000 individual cards. Fourth, the cards were meticulously labeled and organized. Finally, and most importantly, the Quackenbush collection had been preserved over the years. No dust. No shoe boxes.

The Thousand Islands are unquestionably an excellent subject for developing any postcard collection. Few other regions of North America have ever attracted the level of interest by card publishers, and rightly so. The first 35 miles of the St. Lawrence River in Upstate New York and southeastern Ontario are of incomparable natural beauty. Geologic history is measured in billions of years. Human history includes important Native American tribes and the earliest European explorers. Imperial conflicts were often focused and sometimes decided on the shores of the St. Lawrence River. And the Thousand Islands became a premier North American tourist destination coincident with the genesis of the picture postal mail card in the late 1880s.

Decades before the motorcar, the New York Central Railroad and Canadian National Railway made travel to the Thousand Islands convenient for almost everyone, not just the wealthy. Steamships brought them from the rail depots in Clayton and Gananoque to the dozens of resorts, hotels, religious camps, and island communities on both sides of the river. At the same time, postcards of the Thousand Islands became available for all who wanted to send "Having a Wonderful Time, Wish You Were Here" messages to friends and relatives back in Philadelphia or Toronto. The penny postcard and popularity of the Thousand Islands were intertwined. The Quackenbush collection reflects this exciting period and the immense beauty of the Thousand Islands region. Frederick, Windsor, and I hope you will enjoy these views of a bygone era.

—Fred H. Rollins, March 2009

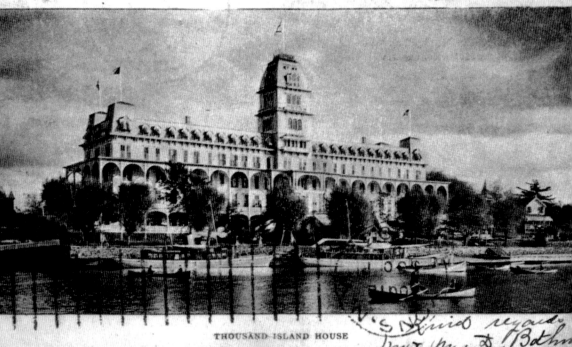

*August 12 . 1903*
*All's well .*

THOUSAND ISLAND HOUSE

"All's well" at the Thousand Island House in Alexandria Bay in 1903. Private yachts, tour boats, and fishing skiffs are ready to take resort guests out for an afternoon on the St. Lawrence River. This black-and-white card is a very rare example of the private mailing cards produced in the United States between 1898 and 1903. Authorized (literally) by an official act of Congress in May 1898, many were wider than most other cards but had limited space for the sender's message (the entire back side was "address only"). They quickly became obsolete after 1907 when mass-produced, higher-quality postcards flooded the market with full images on the front and half of the back side left blank for the sender's message. That standard continues today.

# *One*

# ISLANDS AND RIVER SCENES

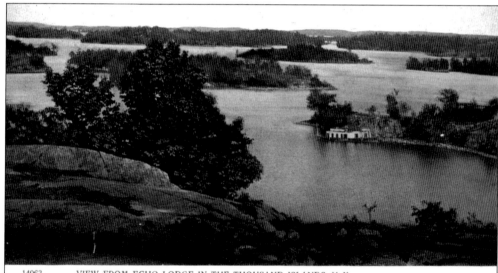

14063.  VIEW FROM ECHO LODGE IN THE THOUSAND ISLANDS, N. Y.

PRINTED IN GERMANY FOR G. W. MORRIS, PORTLAND, ME.

As the last ice age ended and mile-thick glaciers receded to the north, their meltwater formed a vast inland freshwater sea that originally drained eastward to the Atlantic Ocean through the Mohawk and Hudson Valleys. When the land in Upstate New York rose after being freed from the weight of the glaciers, this drainage course to the sea became blocked. Over time, the water found a new exit to the northeast, creating what are now the St. Lawrence River and the Thousand Islands.

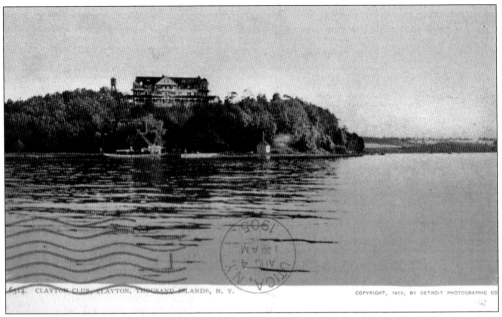

Originally the Hotel Manatauck (see page 73), the Clayton Club was situated on the top of the bluff at Bartlett Point on the upriver end of French Bay. The Detroit Photographic Company published this card and was well known for its top-quality products. Its principal competition in the market for Thousand Islands postcards was high-end German and British publishers.

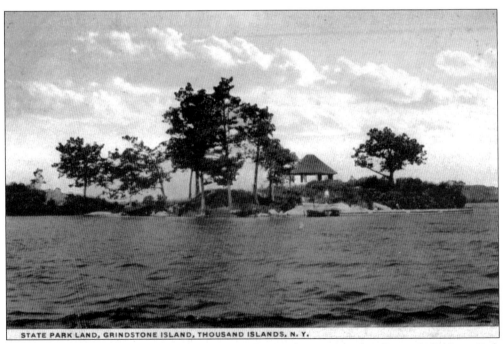

Picnic Point juts into Eel Bay from Grindstone Island and is connected to Canoe Point State Park by a footpath. A pavilion has stood on the rocky point for over 90 years, although the current structure is a replica of the original, which was burned by vandals.

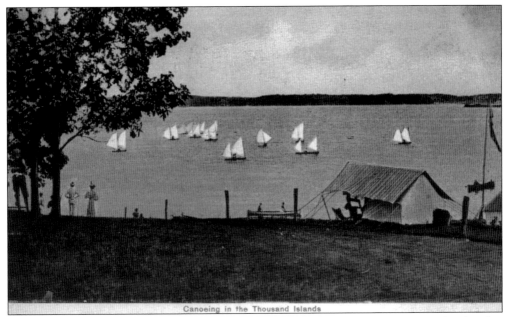

Canoeing in the Thousand Islands

Canoe Point on the northeast end of Grindstone Island is the appropriate location for this shot of double-masted sailing canoes racing. The American Canoe Association owned the property, which is now a state park and accessible only by water. Eel Bay and Wellesley Island are in the background.

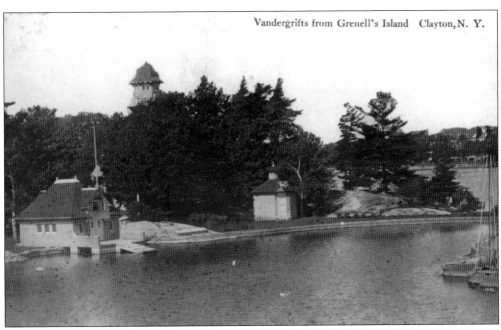

Vandergrifts from Grenell's Island Clayton, N. Y.

Pittsburgh Steel's Vandergrift family owned Long Rock Island, which would be part of Grenell Island near Thousand Island Park except for a narrow channel that separates the two.

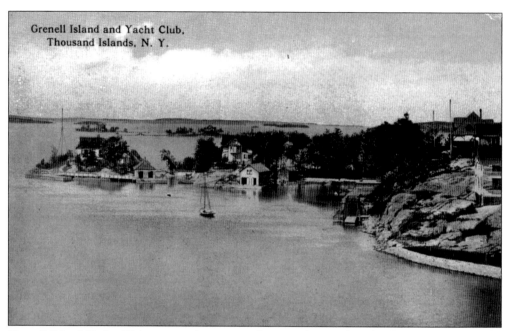

Grenell Island Yacht Club was a private operation catering to the island's summer residents. Sailboats and smaller motor craft were kept in boathouses in front of several clubhouses, which provided a meeting place and social venue for the islanders. All the former club facilities are now private cottages.

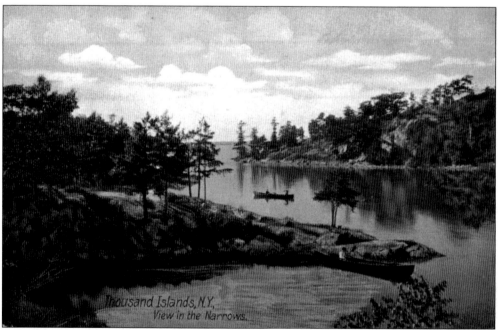

The Narrows separate Wellesley Island from Murray Island and provide access to Eel Bay, a large expanse of water in the middle of the river that can easily be confused with a lake. During the Prohibition era in the 1920s, the Narrows was often used by local rumrunners to smuggle liquor into the United States from Canada under cover of night.

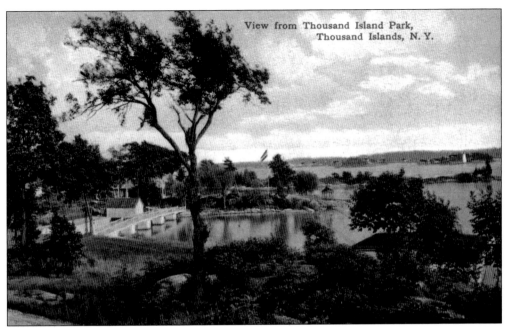

This southeast view from Coast Avenue East in Thousand Island Park includes the long-ago dismantled footbridge that crossed the cove to Wegman Point. A public swimming area now occupies the shore in the left foreground. Rock Island Light in front of Fishers Landing is in the right background.

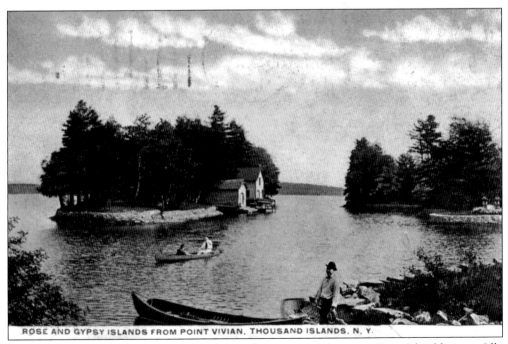

ROSE AND GYPSY ISLANDS FROM POINT VIVIAN, THOUSAND ISLANDS, N. Y.

Many of the Thousand Islands have had several names over the years. Rose Island became Idle Isle after an ownership change. It lies off Point Vivian, a small community of cottages on the New York mainland halfway between Alexandria Bay and the Thousand Islands Bridge.

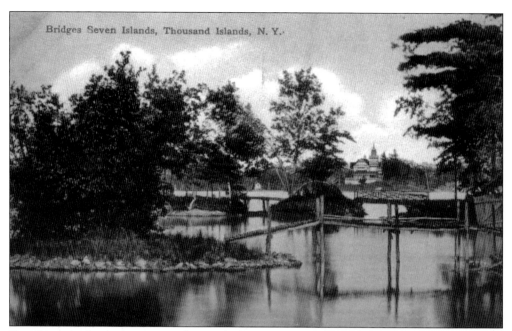

Decades ago, there were seven islets at the lower end of Densmore Bay on Wellesley Island. Time and landfill for cottages have reduced them to two, both accessible by car, and they are nevertheless called Seven Isles. The large cottage in the background still stands, minus the tower, on the New York mainland just upriver from the entrance to Keewaydin State Park Marina.

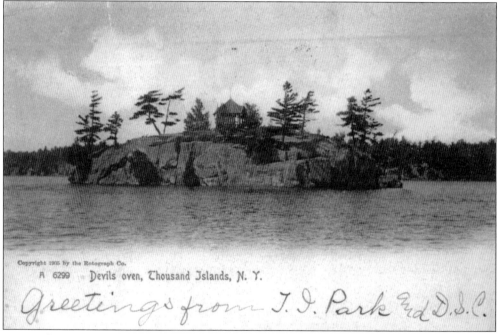

During the Patriot's War of the 1830s, self-styled pirate Bill Johnston allegedly hid out for months in the small cave in the Devil's Oven upriver from Cherry Island after he and others looted and burned the British steamer *Sir Robert Peel*. While the tour boats understandably continue to play up his adventures, Johnston was not much more than a petty rabble-rouser.

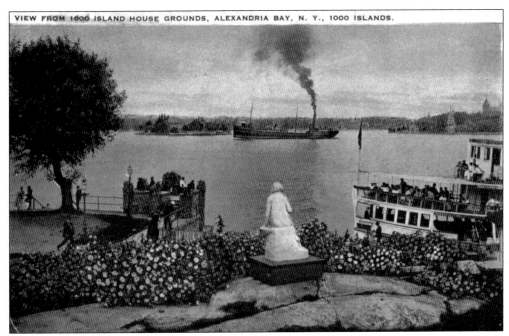

Today Alexandria Bay's River Hospital is located where the Thousand Island House once stood. An excursion boat accepts passengers on the wharf while a pre–St. Lawrence Seaway canaller steams up the river in front of Imperial Island. Boldt Castle looms in the right background.

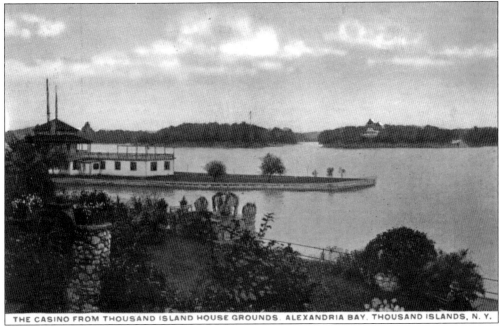

THE CASINO FROM THOUSAND ISLAND HOUSE GROUNDS. ALEXANDRIA BAY. THOUSAND ISLANDS, N. Y.

Casino Island in front of Alexandria Bay is aptly named, although the casino building is long gone. The island is now part of and connected to the village park by a footbridge mimicking the Thousand Islands Bridge. The original cottage on St. Elmo Island is prominent in the right background.

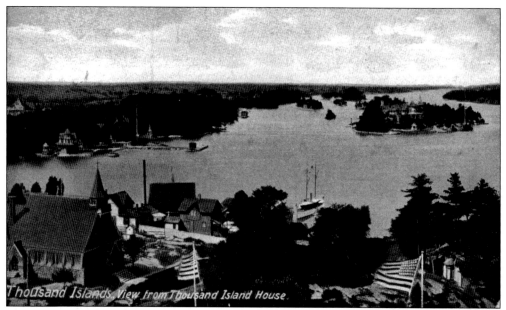

"Spectacular" and "breathtaking" might have described the view upriver from the Thousand Island House in Alexandria Bay around 1925. In the lower left corner is the Church of St. Lawrence. Across the bay on the left is Edgewood Park, the site of today's Edgewood Resort. Cherry Island, with the twin Abraham and Straus cottages, is the first in the chain that leads upriver toward Keewaydin.

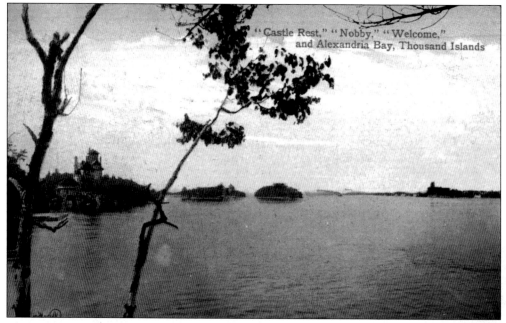

The U.S. Coast Guard station on Wellesley Island across from Alexandria Bay now occupies the site of this illustration of Millionaire's Row. George Pullman's Castle Rest is on the left, and Nobby Island is in the middle, but the right-hand island is Dewey (also known as Friendly) Island and not Welcome Island as the card suggests. The Thousand Island House in Alexandria Bay is on the extreme right.

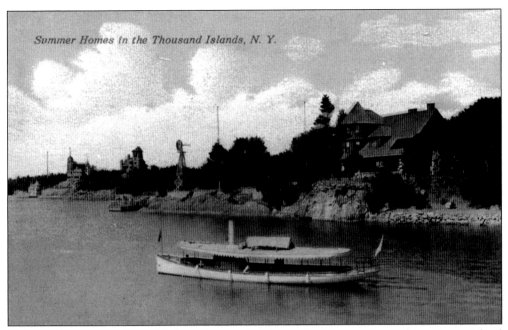

*Summer Homes in the Thousand Islands, N. Y.*

This card is a reverse view of the previous card, this time looking southwest from Dewey Island toward Wellesley Island. Nobby Island, Castle Rest, and Hopewell Hall are visible.

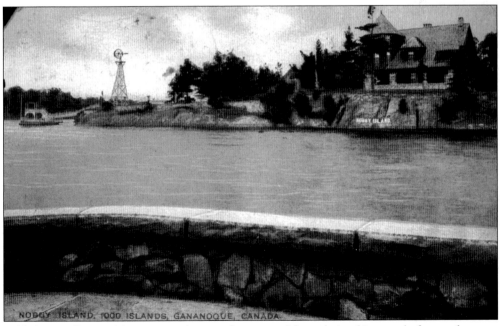

NOBBY ISLAND, 1000 ISLANDS, GANANOQUE, CANADA

Publishers in distant cities or countries were far removed from their subjects and often made errors captioning their postcards. This card shows another view of Nobby Island, which is on Millionaire's Row in American waters across from Alexandria Bay, about 12 miles from Gananoque.

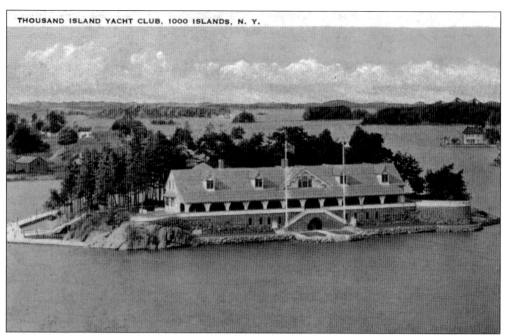

Tucked in the peaceful waters behind Millionaire's Row and in front of the Thousand Islands Club, Welcome Island was home to the Thousand Island Yacht Club until the 1930s. The yacht club was a focal point of high society in the islands during the Gilded Age from the 1880s through to the Great Depression.

George C. Boldt's system of canals on the lower end of Wellesley Island behind Tennis Island served several purposes. His guests could row or paddle small craft on quiet waters on lazy summer days. Water taxis delivered the guests from among the various cottages and recreation facilities to his castle on Heart Island, and the canals carried produce from the Boldt farm on Wellesley Island's interior to the castle and his hotels in New York and Philadelphia.

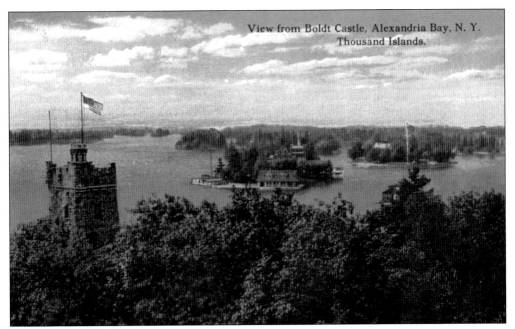

The roof of Boldt Castle on Heart Island provides the vantage point for this scene looking upriver along Millionaire's Row. The cottage on Just Room Enough Island peaks out from behind the trees on the right side. Imperial Island is in the middle background, with Belle Island behind and to the right.

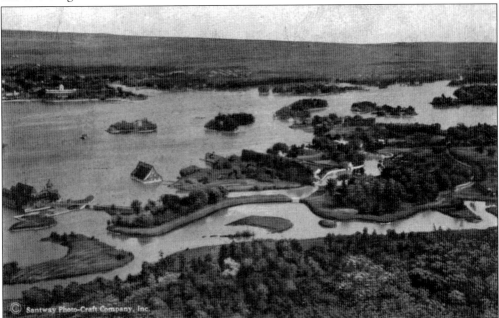

Boldt's yacht house and the Peacock boathouse figure prominently on the left of this aerial view of lower Wellesley Island and Millionaire's Row. The yacht house is now open to the public as part of the Boldt Castle attraction. The Peacock structure housed the watercraft and boat operators for the Peacock cottage on Belle Island. After decades in disrepair, it burned in a winter fire in the 1990s.

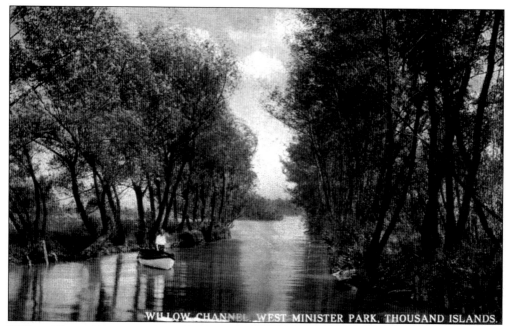

Willow Channel between Mary Island and the extreme lower end of Wellesley Island has filled in with dead branches, silt, and debris over the years. Even if one could find it in the tangle of overhanging willows, getting through in a boat is nearly impossible.

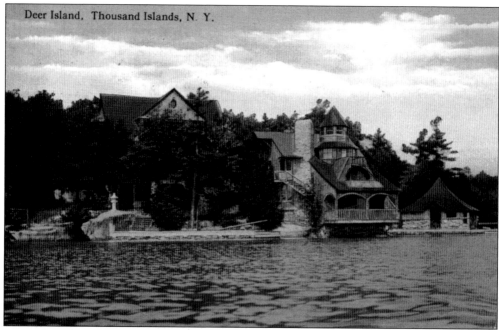

Deer Island is owned by the Skull and Bones Society from Yale University. One of several cottages on the island that have burned down over the years, this one used to face the seaway channel where Light 186 now stands. The water just off the overhanging front porch is over 90 feet deep.

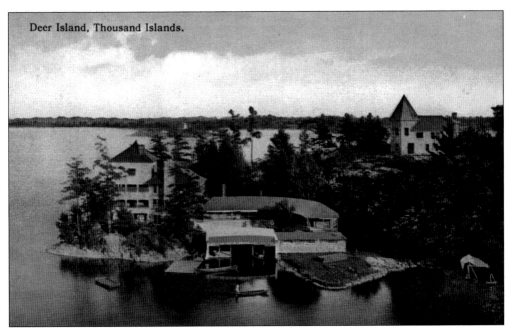

Another of the Deer Island cottages, this one is on the downriver end. The cottage on the bluff to the right is gone. Dingman Point on the New York mainland is across the ship channel in the background.

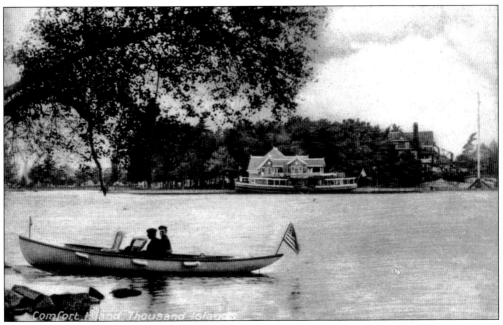

Comfort Island Thousand Islands

This card is mislabeled "Comfort Island." It is actually a view of the boathouse and main cottage on Sport Island in the Summerland Group. The yacht is the *Sport*.

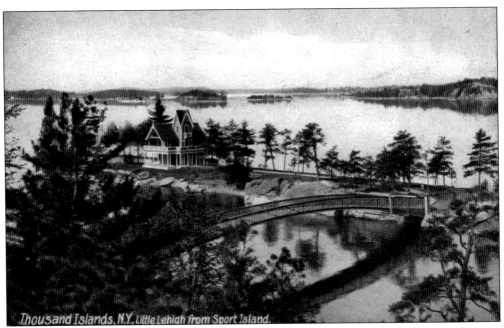

Although rusty and in need of considerable repair to its plank deck, the iron bridge still spans the gap between Sport and Little Lehigh Islands. Taken from the roof of the main cottage on Sport Island, the upriver view shows Grenadier Island in Canada in the right background.

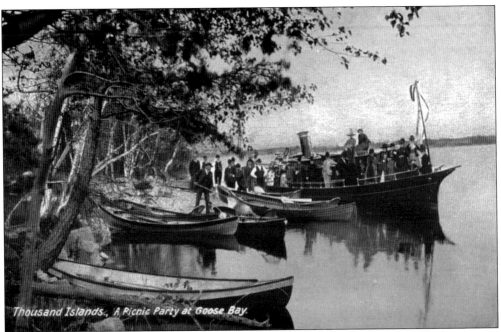

A steam yacht has towed a small fleet of St. Lawrence skiffs to a secluded spot in Goose Bay for a summer afternoon picnic about 1920. In the right background, Kring Point at the entrance to Goose Bay is now one of several parks in the Thousand Island region of the New York State parks system.

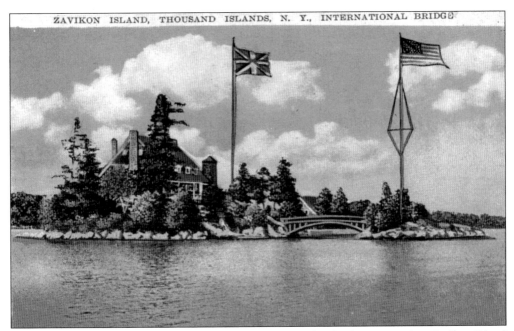

Tour boat announcers have perpetuated the myth that the footbridge connecting Zavikon Island with a smaller islet is the "shortest international bridge in the world." While that claim might be disputed on fact alone, this is not an international bridge at all. The border between the United States and Canada is actually several hundred yards south of the islands.

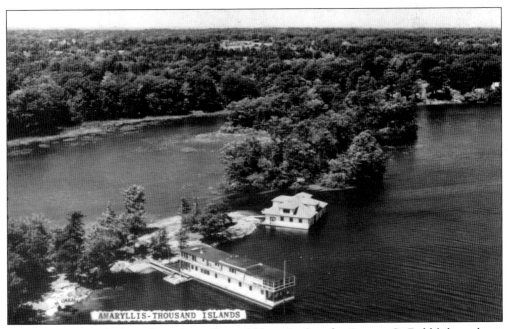

AMARYLLIS - THOUSAND ISLANDS

From a distance, the houseboat *Amaryllis* could be mistaken for George C. Boldt's houseboat, *La Duchesse*, which is moored at the Antique Boat Museum, but the *Amaryllis* is quite different structurally. In recent years, she has been used as a bed-and-breakfast at her mooring off the east end of Hill Island just yards across the border from Westminster Park on Wellesley Island.

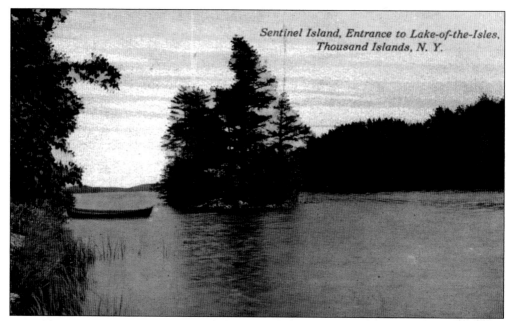

*Sentinel Island, Entrance to Lake-of-the-Isles,*
*Thousand Islands, N. Y.*

Sentinel Island (also called the Sentinel) has guarded the downriver entrance to Lake of the Isles since the end of the ice age and the creation of the St. Lawrence River about 10,000 years ago. On summer days, a steady parade of pleasure craft passes the Sentinel as it makes its way into or out of the lake.

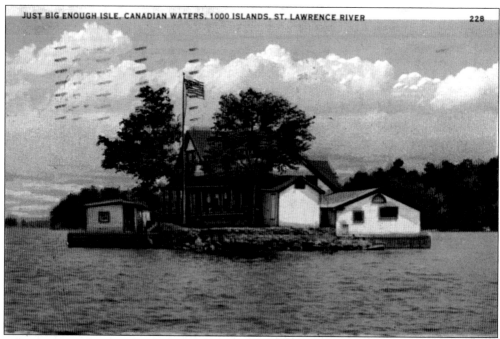

JUST BIG ENOUGH ISLE. CANADIAN WATERS. 1000 ISLANDS. ST. LAWRENCE RIVER       228

Even the smallest of rock islets can provide the foundation for a cottage, and Just Big Enough is barely that. The islet lies off Club Island beside the Canadian Middle Channel near Rockport, Ontario. Sewage disposal issues notwithstanding, many cottage owners find paradise on their own small piece of the Thousand Islands.

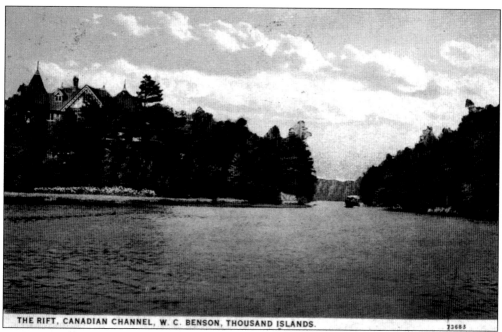

THE RIFT, CANADIAN CHANNEL, W. C. BENSON, THOUSAND ISLANDS.

Tour boats used to thread narrow Benson's Rift to view the colorful flower beds planted along the shore. With the introduction of much larger vessels in the 1970s and 1980s, tour operators dropped the route, which undoubtedly pleased the cottage owners along the rift. The imposing cottage still looks down on the narrow channel between Hill and Rabbit Islands.

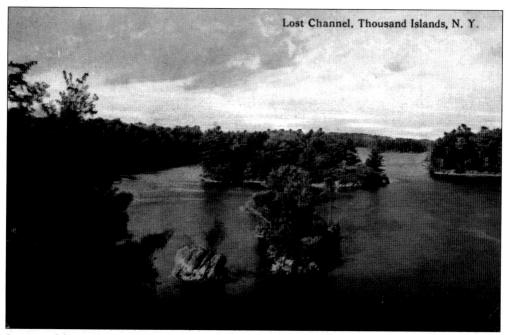

Lost Channel, Thousand Islands, N. Y.

So named because a British war boat patrol became hopelessly lost in its maze of islands in August 1760 during the French and Indian War, the Lost Channel is under the arch section of the Canadian span of the Thousand Islands Bridge.

The border between the United States and Canada snakes through the Thousand Islands, never bisecting any one island and equally dividing the landmass between the two countries (although more individual islands are in Canada). In many spots, including the International Rift between Wellesley and Hill Islands, a few feet of water is all that separates the two neighboring countries.

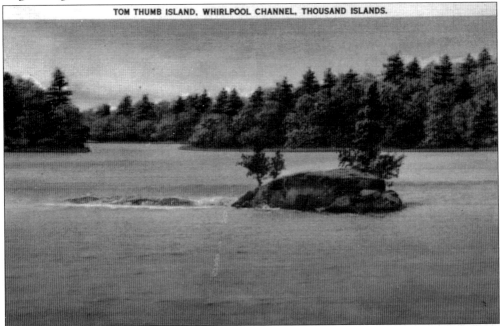

Tom Thumb Island may have dozens of challengers as "the smallest of the Thousand Islands," but its position along most tour boat routes seals its superlative claim. To earn classification as an island requires a rock to support at least two pieces of significant vegetation and protrude above the water year-round.

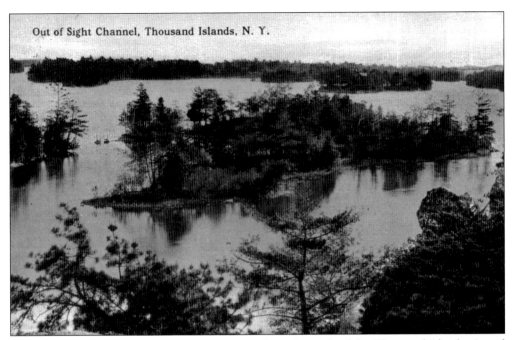

Out of Sight Channel, Thousand Islands, N. Y.

Calm waters reflect the signature evergreens and granite rock of the Thousand Islands viewed from the overlook above the Out of Sight Channel near Ivy Lea.

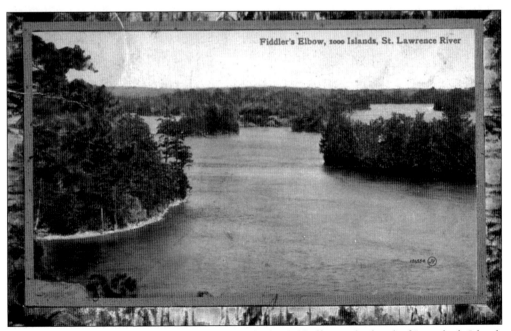

Fiddler's Elbow, 1000 Islands, St. Lawrence River

This view of Fiddler's Elbow was taken from the high bluff near the head of Lynedoch Island, looking south across to Wallace Island on the left. The "fiddler's forearm" to the left is a major thoroughfare for tour boats and pleasure craft on summer days.

27

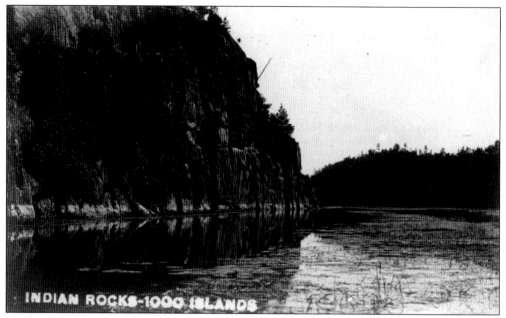

Indian Rocks form a sharp cliff along the northwest shore of Landon Bay, which cuts a mile-long cleft into the Canadian mainland behind Stave Island. Canoeists venturing to the far end of the bay are rewarded with a small stream cascading down a set of rock steps into the bay.

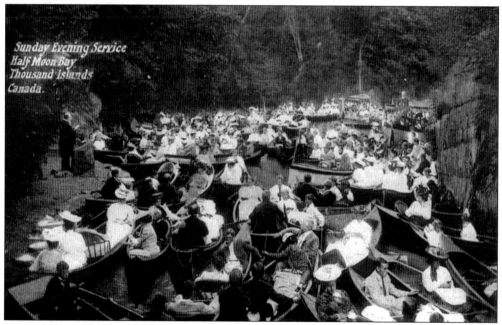

Since 1887, Half Moon Bay on Bostwick Island has hosted outdoor Sunday vesper services. While the crowds are thinner and the boats larger, churchgoers still enjoy this unique setting and natural beauty of the tiny crescent-shaped bay.

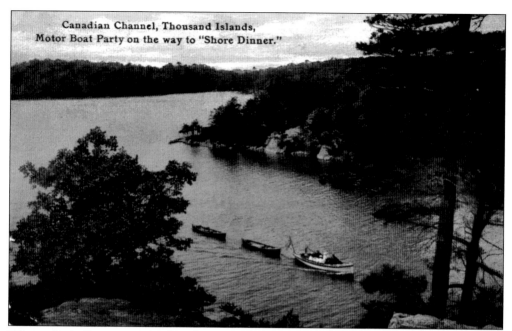

The method of transportation has changed dramatically over the decades since this illustration was created about 1930, but a shore dinner prepared by a professional fishing guide after a day of fishing has not. Panfried over an open fire, bass and pike are favorites at shore dinners in the Thousand Islands.

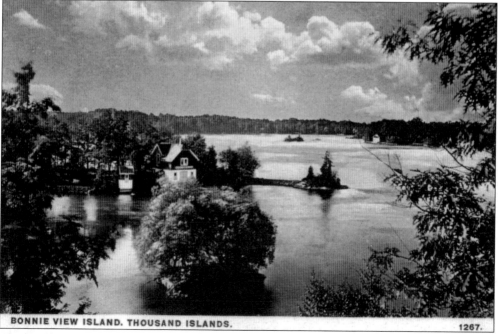

This card was produced by Canada Steamship Lines (CSL) as part of its promotion of the islands and steamship connections with Montreal and Toronto. CSL ended passenger service on the St. Lawrence River after World War II. Today massive CSL lakers carry iron ore, grain, and other dry bulk cargoes along the St. Lawrence Seaway.

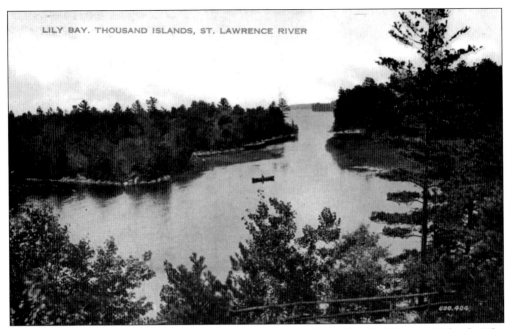

LILY BAY. THOUSAND ISLANDS, ST. LAWRENCE RIVER

Quiet spots to fish or just languish on a warm afternoon abound in the Thousand Islands. The natural beauty and serenity of hidden bays have attracted people to the islands for thousands of years. The Iroquois Nation called the area the "Garden of the Great Spirit."

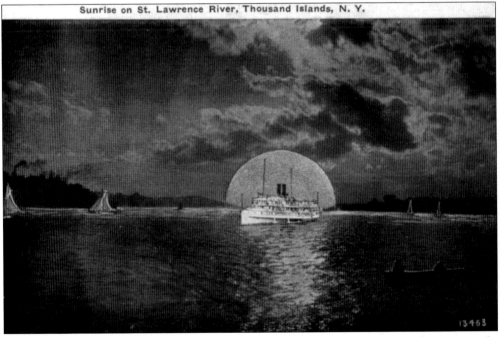

Sunrise on St. Lawrence River, Thousand Islands, N. Y.

Exaggerating objects or embellishing scenes to increase sales was common in antique postcards, particularly those not based on an actual photograph. With a grossly oversize sun and out-before-dawn sailboats, this card is a perfect example of "postcard license."

## Two

# CASTLES AND MANSIONS

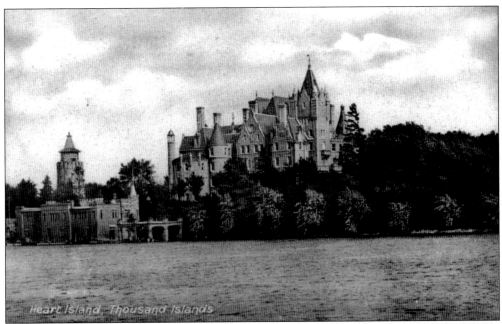

Heart Island, Thousand Islands

Boldt Castle on Heart Island is the best known of all the castles in the Thousand Islands. Viewed here from the northwest, the massive structure was built by George C. Boldt, a New York and Philadelphia hotel magnate, for his wife, Louise. When she unexpectedly died in 1904, work was stopped, and the building was never completed. After decades of neglect and decay, the Thousand Islands Bridge Authority acquired the property and has since undertaken a thorough restoration project.

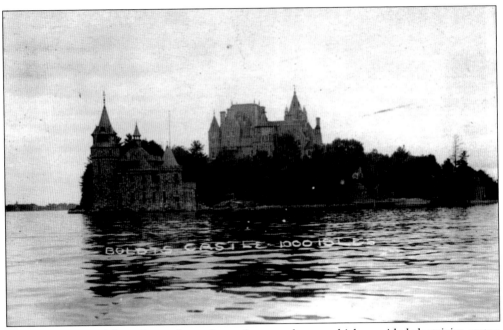

Boldt Castle viewed from the northeast shows the powerhouse, which provided electricity, water, and heat to all the structures on the island.

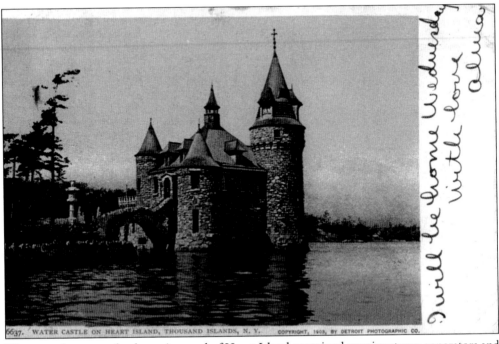

The powerhouse on the downriver end of Heart Island contained massive steam generators and pumps. The peak of the tallest tower included a four-faced clock with chimes. Destroyed by fire in the 1930s, the powerhouse and clock have been expertly restored by the Thousand Islands Bridge Authority.

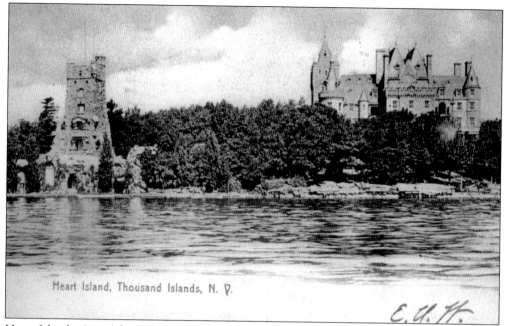

Heart Island, Thousand Islands, N. Y.

Heart Island, viewed from the south, shows the Alster Tower at left. It was built as a playhouse for George C. Boldt's children and their friends, although it was occupied by the entire Boldt family while the main castle building was under construction beginning in 1898.

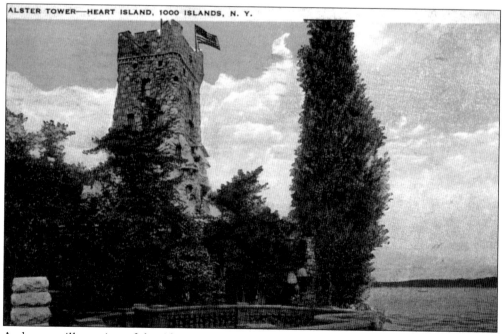

ALSTER TOWER—HEART ISLAND, 1000 ISLANDS, N. Y.

A close-up illustration of the Alster Tower shows off its fanciful architecture. Included on its lower levels were a bowling alley, a theater, and a swimming pool.

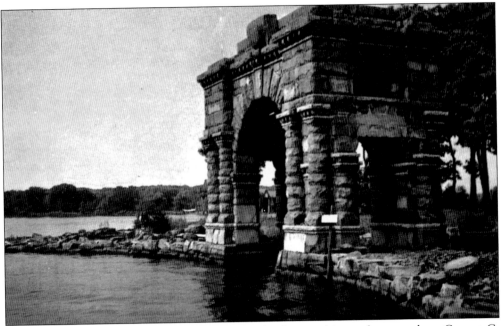

The huge stone arch on the west end of Heart Island opened into a lagoon where George C. Boldt's guests were to arrive and be greeted.

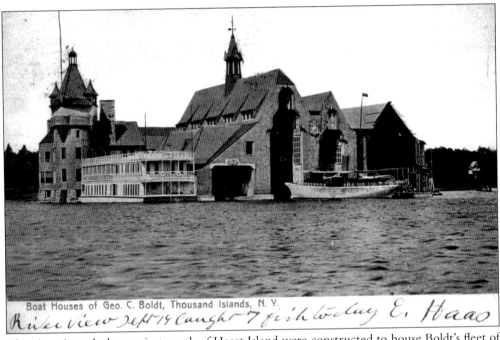

Boat Houses of Geo. C. Boldt, Thousand Islands, N. Y.

The gigantic yacht houses just north of Heart Island were constructed to house Boldt's fleet of yachts, motor launches, runabouts, and skiffs. His crews lived in the apartment complex on the left side of the building. Boldt's houseboat *La Duchesse* is moored on the left. For many years, she was owned by the McNally family and is now on display at the Antique Boat Museum.

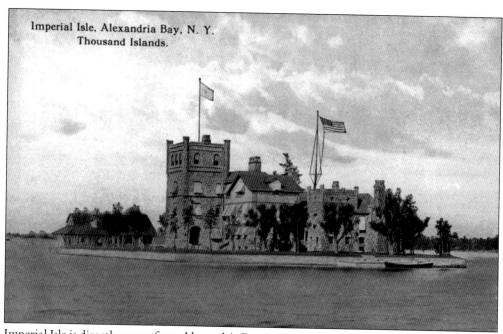

Imperial Isle, Alexandria Bay, N. Y.
Thousand Islands.

Imperial Isle is directly across from Alexandria Bay, just upriver from Boldt Castle. The impressive mansion was built by Gilbert Rafferty, a Pittsburgh industrialist, in the 1890s. It was demolished in the 1960s and replaced by a modern and more modest cottage.

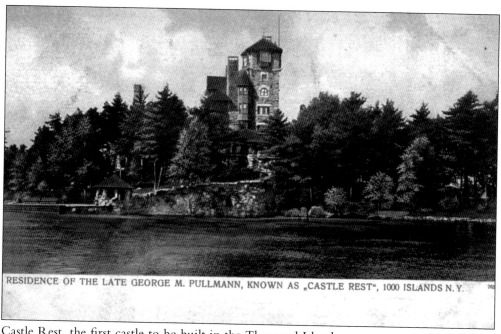

RESIDENCE OF THE LATE GEORGE M. PULLMANN, KNOWN AS „CASTLE REST", 1000 ISLANDS N. Y.

Castle Rest, the first castle to be built in the Thousand Islands, was constructed in 1888 for George Pullman of railroad car fame. This view shows the east side of the island.

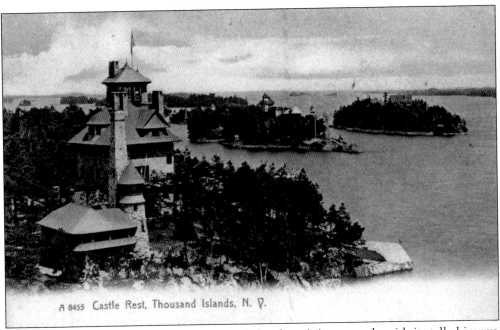

This view of the west side of Castle Rest includes the miniature castle with its tall chimney. The building was originally the servants' quarters and was used by the owners after the main castle was razed.

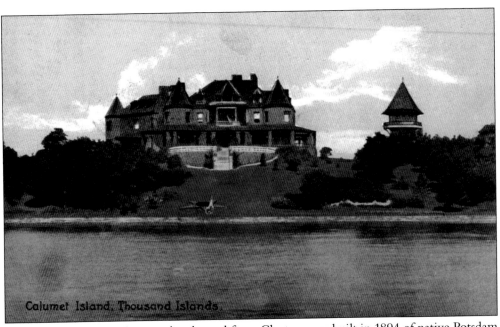

Calumet Castle, located across the channel from Clayton, was built in 1894 of native Potsdam granite for Charles G. Emery, treasurer of the American Tobacco Company and owner of the nearby Frontenac Hotel. This view shows the castle and its water tower shortly after construction.

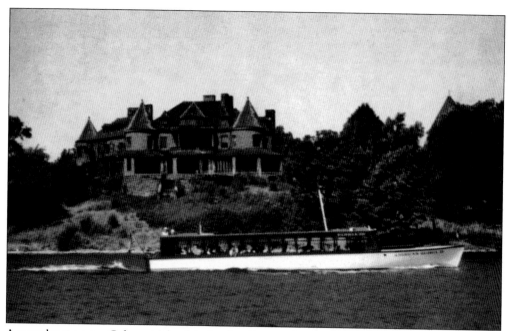

A tour boat passes Calumet Island in its derelict condition a few years prior to a destructive fire in 1955. The water tower survives to this day, and a light in its upper section continues to provide a nighttime beacon for boaters in the area.

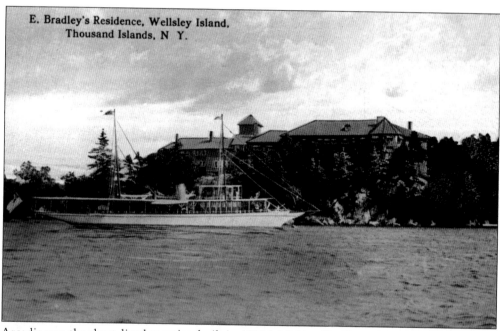

Arcadia was the short-lived mansion built in 1915 by Edson Bradley, a New York distiller, on the north side of Wellesley Island. At nearly 300 feet long, it was the largest bungalow–style building ever erected. It was destroyed in a fire in 1922. The entire Bradley property is now part of Wellesley Island State Park.

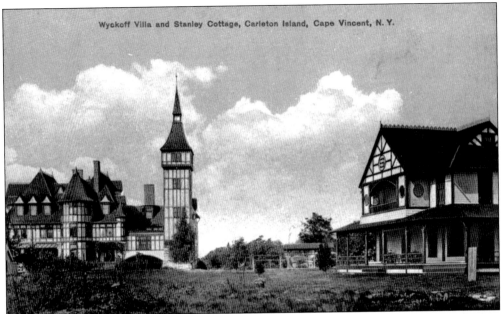

Remington typewriter magnate William O. Wyckoff built Carleton Villa in 1895 at the head of Carleton Island, a short distance downriver from Cape Vincent. However, he and his wife never were able to enjoy their castle. She died from cancer prior to their moving in, and Wyckoff died of a heart attack on his first night there in July 1895.

Carleton Island, Cape Vincent, N. Y.

Rising over the South Bay community, Carleton Villa enjoys sweeping vistas toward Cape Vincent to the left, Wolfe Island in the right background, and Lake Ontario in the middle distance. The tower is gone, and the main building, unoccupied for over 60 years, is in serious disrepair.

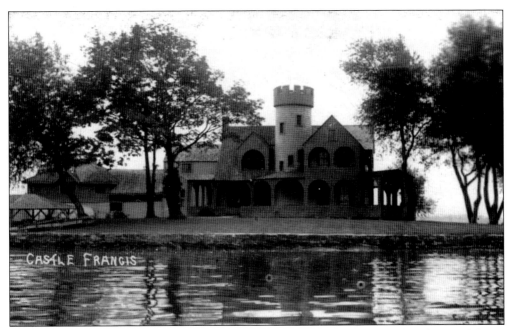

Castle Francis was located on a small island in front of Thousand Island Park. The wood frame structure burned in the 1950s.

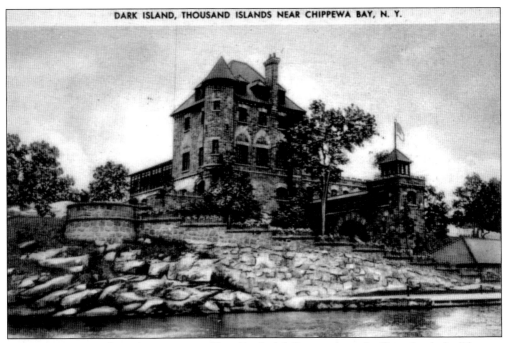

DARK ISLAND, THOUSAND ISLANDS NEAR CHIPPEWA BAY, N. Y.

Singer Sewing Machine Company president Frederick Bourne kept the "hunting lodge" he was building on Dark Island a secret from his family. Today his creation (complete with dungeons and secret passages) is operated as an inn and attraction that is accessible by private boat or tour operation.

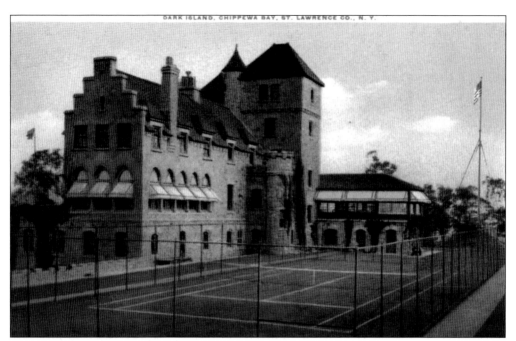

Originally called the Towers and later Jorstadt Castle, Frederick Bourne's creation was recently renamed Singer Castle to commemorate his company. The castle remained in the Bourne family for nearly 60 years.

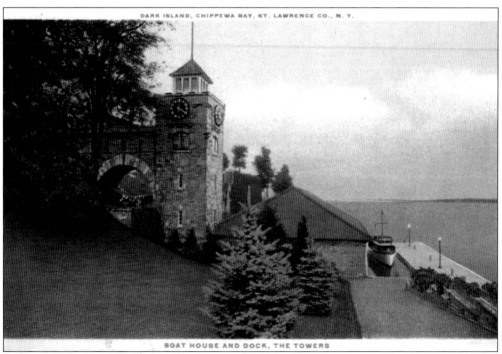

BOAT HOUSE AND DOCK, THE TOWERS

Dark Island sits astride the seaway channel opposite Chippewa Bay, several miles below Alexandria Bay. This scene includes the three-faced, chimed clock tower and the boathouse and main dock on the channel side of the island.

VIEW FROM DOCK, THE TOWERS

Beautiful gardens surround Singer Castle. Stone walkways lead up from the water's edge to the castle on the island's spine, and paths lead out to spectacular river vistas at either end of the island.

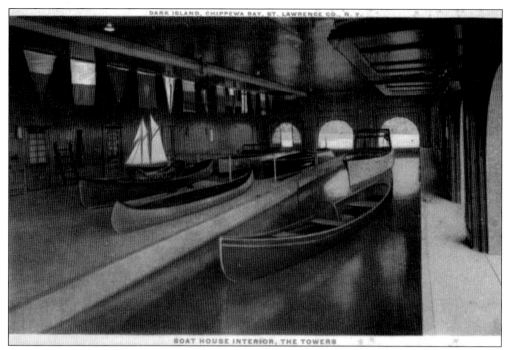

Shown here is the interior of the front boathouse on Dark Island with a number of vintage launches and skiffs. The larger boathouse on the island's back side originally contained a squash court, but the structure is now in considerable disrepair.

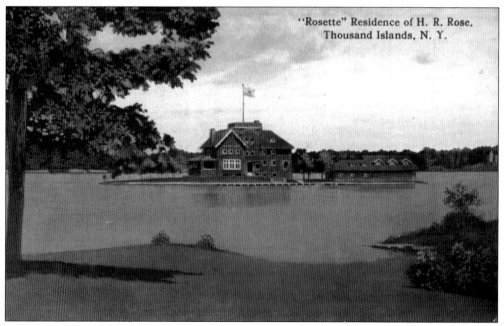

Longue Vue Island between Alexandria Bay and Point Vivian was a rock shoal before its first owner brought in stone and dirt fill to create an island for the miniature castle he called Rosette. For obvious reasons, the island is often referred to as Artificial Island.

# *Three*

# COTTAGES AND SUMMER HOMES

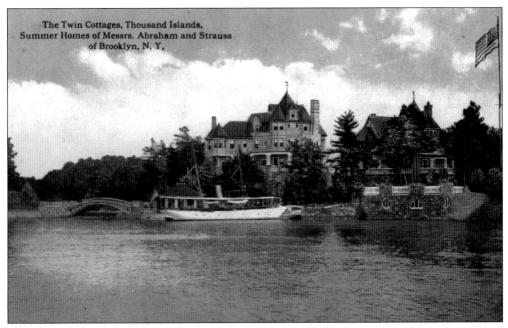

The twin cottages on the lower end of Cherry Island were built by department store partners Abraham Abraham and Nathan Straus, who called their summer homes Olympia and Belora. Abraham died at his cottage in June 1911. Straus and his brother Isidor were partners in another department store, Macy's, until Isidor and his wife died in the sinking of the *Titanic*. Nathan Straus ultimately donated much of his fortune to Zionist causes. Ironically, Abraham and Strauss stores merged with Macy's in 1995.

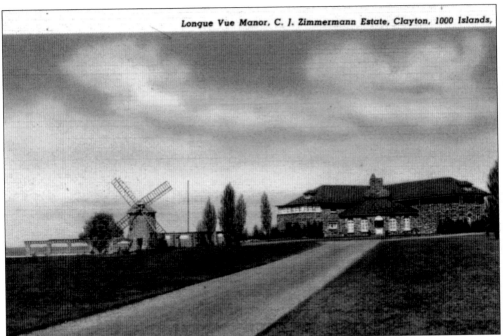

Longue Vue Manor enjoys a panoramic overlook toward Wolfe and Grindstone Islands from its prominent spot southwest of Bartlett Point near Clayton. The estate became a convent and more recently has operated as a restaurant.

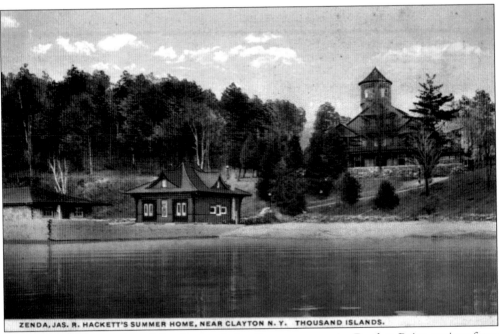

ZENDA, JAS. R. HACKETT'S SUMMER HOME, NEAR CLAYTON N. Y. THOUSAND ISLANDS.

James R. Hackett purchased the farm and riverfront property on Bartlett Point upriver from Clayton and built his summer residence there in the late 1800s. A classical stage actor, director, and silent film star, Hackett chose to name it after the lead role he played in the stage and film productions of *The Prisoner of Zenda*.

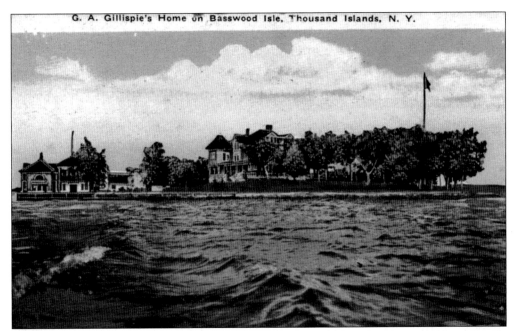

G. A. Gillispie's Home on Basswood Isle, Thousand Islands, N. Y.

Basswood Island lies just south of Maple and Grenell Islands. The large boathouse was intentionally burned in a controlled fire in 1969. The main cottage was lost to an unintentional fire six years later. All that remains of the original structures is the stone pump house on the east end of the island.

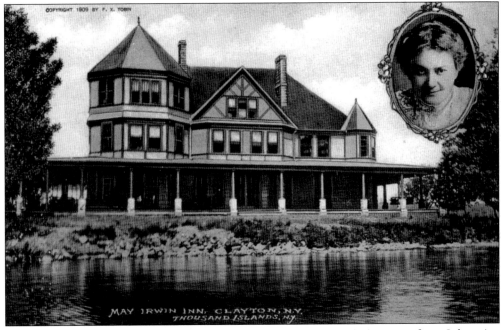

COPYRIGHT 1909 BY F. X. TOBIN

MAY IRWIN INN, CLAYTON, N.Y.
THOUSAND ISLANDS, N.Y.

Singer and stage actress May Irwin must not have had a marketing and advertising firm. Otherwise, a warmer, more inviting photograph might have been used to attract people to the inn she opened in 1922 on Mason's Point downriver from Clayton.

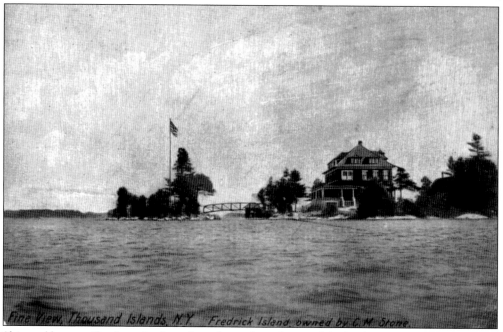

Ship and boat traffic along the American channel southwest of the bridge is easily surveyed from Frederick Island, the most northerly of the group of islands in front of Fishers Landing.

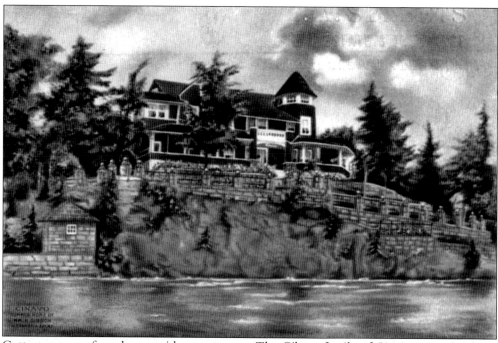

Cottage names often change with new owners. The Gibson family of Cincinnati and Gibson Greeting Card fame called its summer residence at the upper end of Brown Bay Cinova (mislabeled on the card). Later names for subsequent owners were Deva Loca (meaning "God's place" in Hindu) and Forest Cove Lodge. Built about 1895, it is called Manatoana (Iroquois for "garden of the great spirit") and has been in the Bronson A. Quackenbush family since 1955.

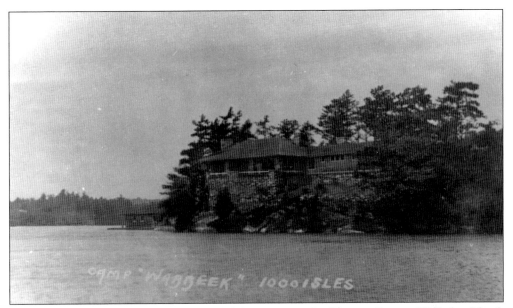

From its perch on the point of land at the downriver end of Brown Bay on Wellesley Island, Wabbeek has a magnificent view upriver to the American span and beyond. It is also known as Granny's Hill and was designed in 1915 by the same architect who did the plans for Edson Bradley's huge bungalow on the north side of Wellesley Island (see page 37).

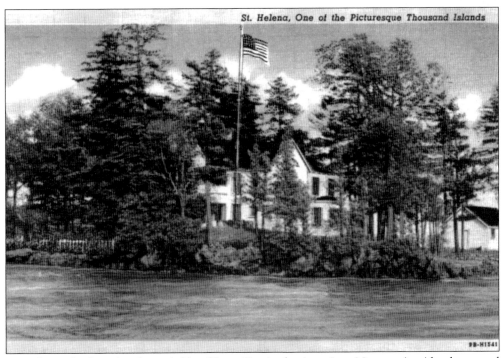

St. Helena Island on the channel side of Swan Bay in the American Narrows is said to be named for the St. Helena Island in the south Atlantic where Napoleon Bonaparte was exiled in 1815.

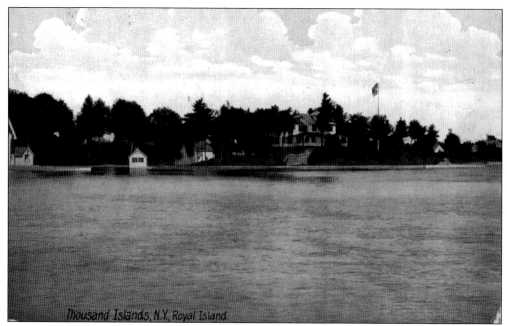

Opposite Point Vivian between Alexandria Bay and the American span, Royal Island (now known as Isle Royale) has been in the McNally family for nearly 100 years. It is connected to Wellesley Island by a footbridge. The houseboat *La Duchesse* was anchored behind the island for many decades before being moved to the Antique Boat Museum in 2005.

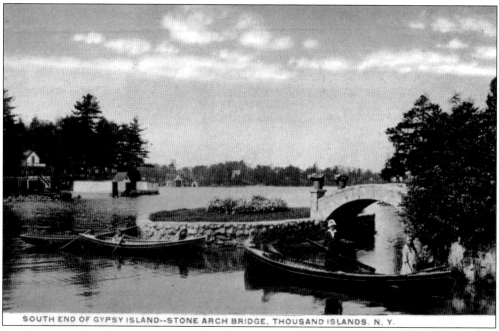

In the years before income tax, wealthy island owners built sprawling, palatial, and richly appointed cottages. Local masons earned a living ornamenting the grounds and shoreline with elaborate stonework as here on Gypsy Island in the American Narrows. Point Vivian is to the left, and Isle Royale sits across the channel along Wellesley Island in the background.

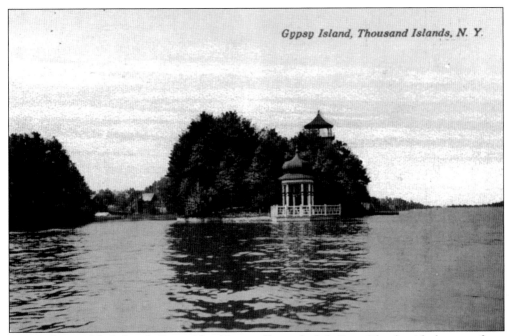

On another mislabeled card, Gypsy Island is actually on the left. Rose Island, with the waterfront gazebo and cupola on the cottage is in the center. This view today would include the arch of the American span in the right background.

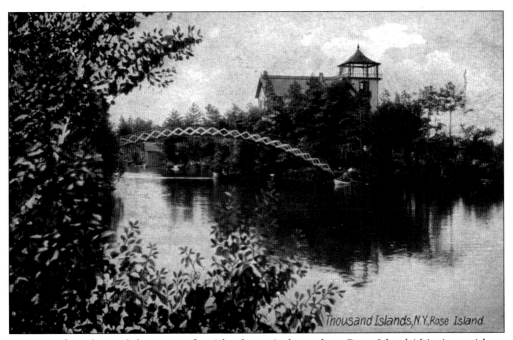

Thousand Islands, N.Y, Rose Island.

Owners often changed the name of an island to suit themselves. Rose Island (this time with an arched footbridge added) was the summer home of W. G. Rose, the mayor of Cleveland, Ohio, in the late 1880s.

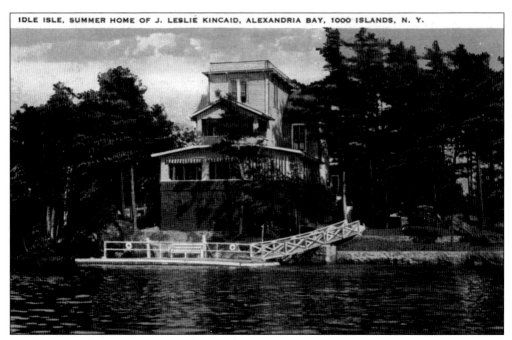

J. Leslie Kincaid, a New York assemblyman from the Syracuse area, purchased Rose Island (minus the cupola) from Mayor W. G. Rose of Cleveland around 1912. Kincaid renamed it Idle Isle.

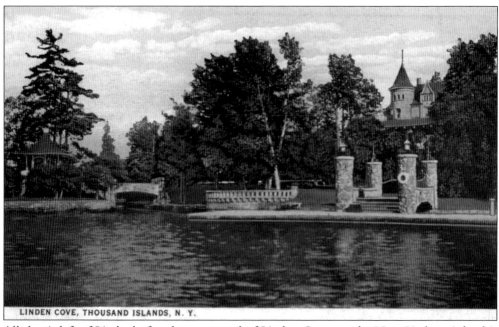

LINDEN COVE, THOUSAND ISLANDS, N. Y.

All that is left of Lindenhof at the upper end of Linden Cove on the New York mainland is some crumbling stonework along the river's edge. A modern cottage occupies the bluff where the small castle once stood.

50

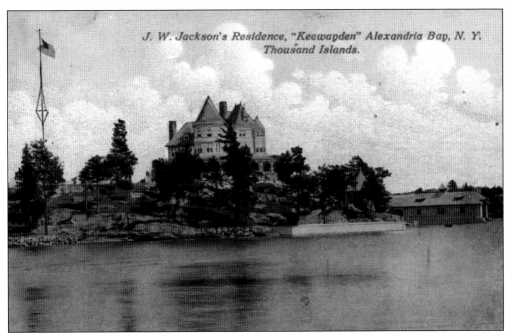

*J. W. Jackson's Residence, "Keewapden" Alexandria Bay, N. Y. Thousand Islands.*

New Jersey industrialist J. W. Jackson's huge summer cottage and boathouse no longer exist. They were razed when the property (now called Keewaydin) became part of the New York State parks system in 1961.

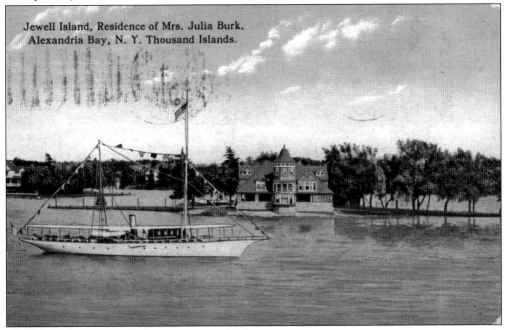

Jewell Island, Residence of Mrs. Julia Burk, Alexandria Bay, N. Y. Thousand Islands.

Stoney Crest is gone, and Jewel Island is smaller today than it was when this image was taken sometime before the construction of the St. Lawrence Seaway in the mid-1950s. To allow for the safe passage of longer and wider ships in the American Narrows above Alexandria Bay, seaway engineers razed the 1888 cottage and lopped 20 feet off the front of the island facing the channel.

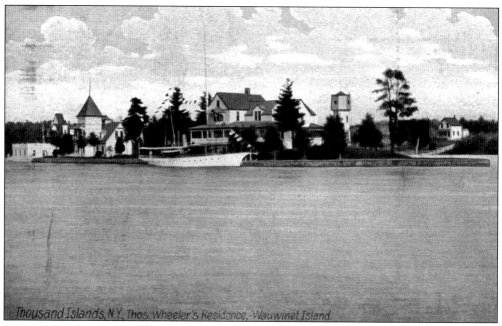

Thomas H. Wheeler spent 40 years with John D. Rockefeller's Standard Oil Company, retiring in 1913. He purchased Wauwinet (correctly spelled Wau-Winet) Island in front of Keewaydin above Alexandria Bay in 1901. The original cottage and a successor structure both burned down. A third and architecturally relevant cottage was recently constructed on the old foundation.

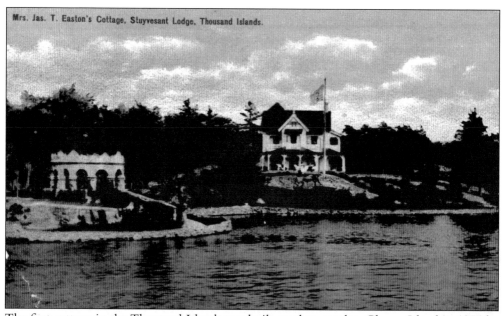

The first cottage in the Thousand Islands was built on then-treeless Cherry Island in 1855 by Rev. George Rockwell of Alexandria Bay. Local entrepreneur and substantial island owner Azariah Walton had stripped most of his islands of their wood to fuel steamships. Unable to sell them as business opportunities, he started a trend by convincing Rockwell to build Stuyvesant Lodge. (Anthony S. Mollica collection.)

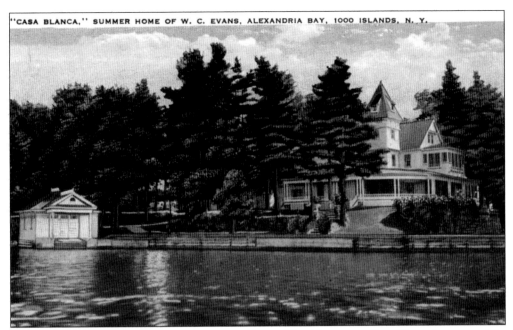

Since the late 1980s, the Victorian cottage on Cherry Island known as Casa Blanca has opened for guided tours and an occasional wedding during the summer months. Visitors reach the island via tour boat from Alexandria Bay. Cherry Island was originally known as Wartleberry Island.

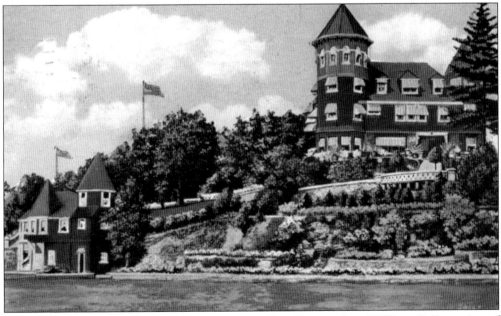

George C. Boldt purchased the 400-acre Hopewell Hall estate from William C. Browning of New York in 1904 to add to his growing collection of properties along the river. The cottage remained in the Boldt family through the 1980s.

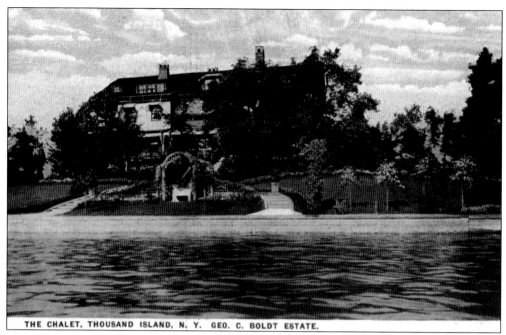

THE CHALET, THOUSAND ISLAND, N. Y. GEO. C. BOLDT ESTATE.

Part of George C. Boldt's expansive holdings on Wellesley Island, the Chalet housed guests and was often leased for the full summer season to his intimate friends. A testimony to his belief in the value of real estate in the Thousand Islands, the Chalet is now a subdivision of privately owned condominiums.

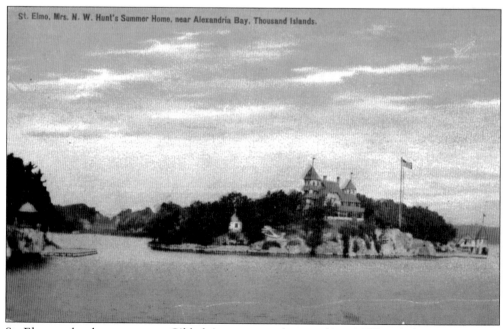

St. Elmo, Mrs. N. W. Hunt's Summer Home, near Alexandria Bay, Thousand Islands.

St. Elmo and a dozen or more Gilded Age summer homes along Millionaire's Row opposite Alexandria Bay are just memories today. Fire destroyed some, and others were torn down to avoid taxes or major upkeep expenses.

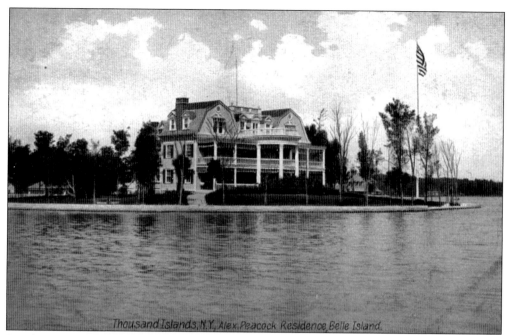

Stately Belle Island was one of the finest summer homes along Millionaire's Row in the Gilded Age. Boldt's huge yacht house looms in the right distance. His Wellesley Island cottage and Tennis Island facilities are hidden in the left background.

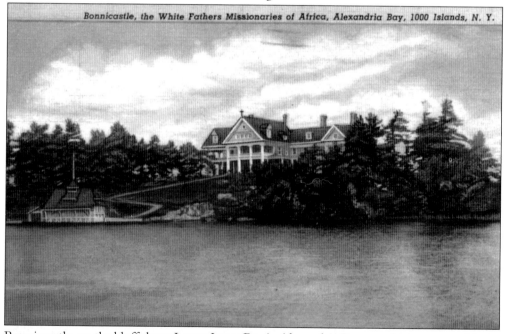

Bonniecastle, on the bluff above Lower James Bay in Alexandria Bay, was the summer residence of Dr. J. G. Holland, founder and early editor of *Scribner's Magazine*. He expanded the original structure that was built in the late 1870s. For a time after 1942, it was owned by the White Fathers of Africa missionaries. Holland's cottage, a variety of newer structures, and an extensive marina operation are now known as Bonnie Castle Resort.

Camp 1812, F. A. Reed, Thousand Islands, near Alexandria Bay, N. Y.

Religious campgrounds began to appear in the Thousand Islands in the 1870s. Thousand Island Park (Methodist), Westminster Park (Presbyterian), and Summerland Island (Universalist), all in New York, and Butternut Bay (Methodist) on the Ontario mainland near Brockville, were some of the largest and most venerable camps. Private owners often used the term *camp* in naming their properties. Over time, however, *cottage* came to rule in the Thousand Islands, but *camp* continues to be the common term describing Adirondack properties.

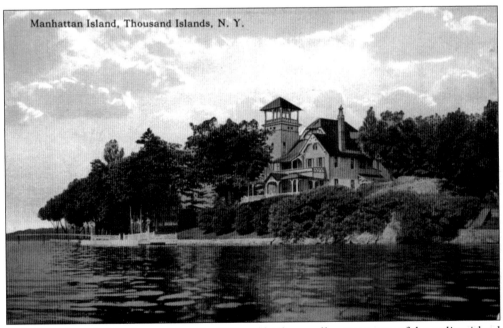

Manhattan Island, Thousand Islands, N. Y.

Seth Green bought Manhattan Island in 1855 and built a small cottage, one of the earliest island cottages. Later Judge J. C. Spencer of New York City bought the island and erected several buildings, including the large cottage that faced the main channel to the south.

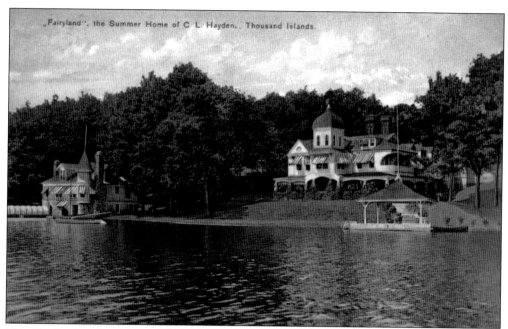

The Hayden brothers from Columbus, Ohio, owned all of Fairyland Island, which was often referred to as Hayden's Island. The island has since been subdivided, but some of the Haydens' cottages remain intact.

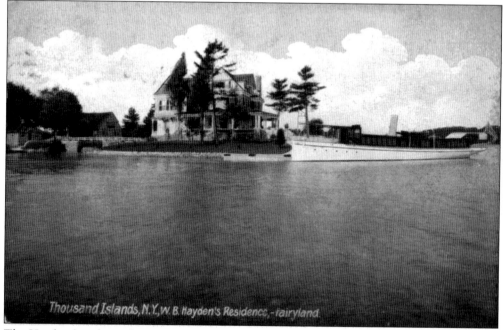

The Haydens' yacht no longer pulls up to the dock beside the cottage, but the large, attractive structure still sits on the islet at the foot of Fairyland Island. A small but sturdy bridge connects the two.

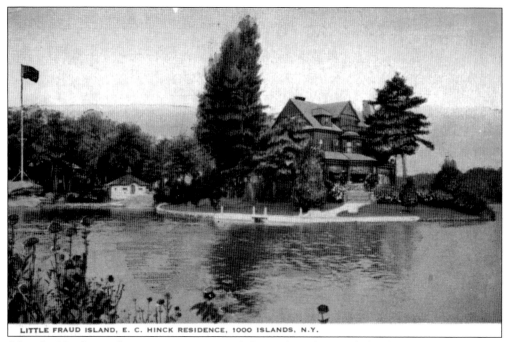

LITTLE FRAUD ISLAND, E. C. HINCK RESIDENCE, 1000 ISLANDS, N.Y.

After the Haydens, subsequent owners named this rock Little Fraud Island. The current owners call their summer home Estrellita, which is Spanish for "little star."

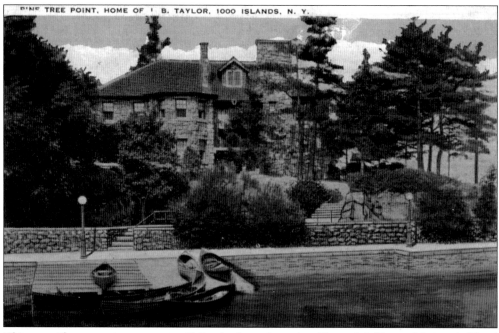

PINE TREE POINT, HOME OF I. B. TAYLOR, 1000 ISLANDS, N. Y.

The magnificent stone structure on Point Anthony between Alexandria Bay and Iroquois Island was originally a private home that burned and was rebuilt. It is now operated as the Pine Tree Point Resort.

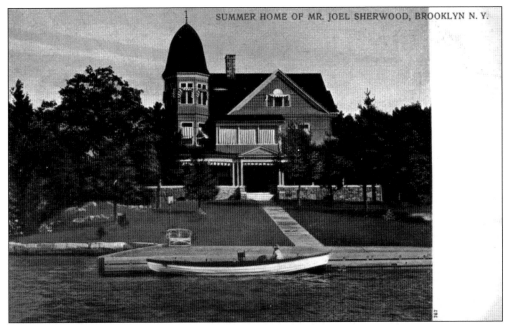

For decades, the Sherwood family cottage was the most prominent structure on Iroquois Island just downriver from Alexandria Bay. Today the island has been largely developed with several more modern cottages.

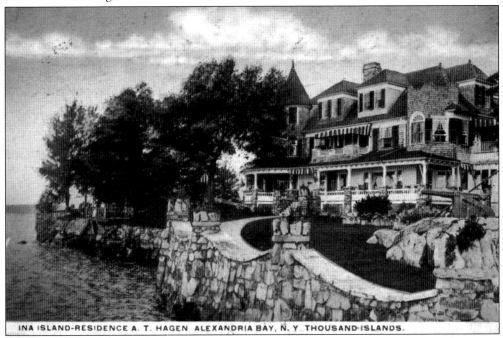

In 1896, Emma Hagen purchased Ina Island in the Summerland Group from Samuel Briggs, one of the early developers in the Thousand Islands. Her husband, Arthur, manufactured industrial laundry equipment and is credited with opening the first Laundromat in the United States. The gigantic boathouse on the back side of the island includes a dance hall on the second floor above the boat slips where the Hagens entertained fellow socialites.

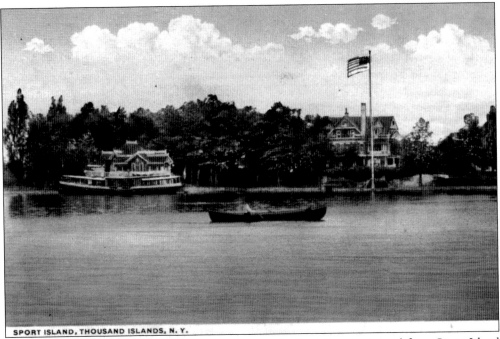

SPORT ISLAND, THOUSAND ISLANDS, N. Y.

Smaller motorboats have long since replaced the yacht *Sport* for trips to and from Sport Island in the Summerland Group or for relaxing excursions among the islands.

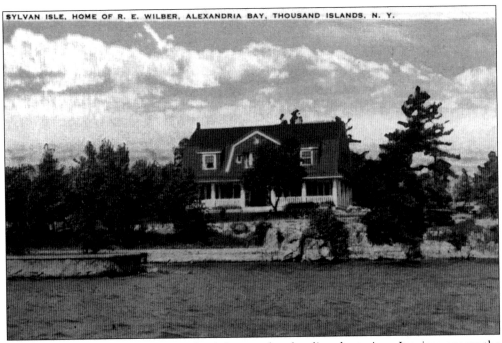

SYLVAN ISLE, HOME OF R. E. WILBER, ALEXANDRIA BAY, THOUSAND ISLANDS, N. Y.

Sylvan Isle is the last of the Summerland Group when heading downriver. Its view sweeps the river between Grenadier Island in Canada and the U.S. mainland at Goose Bay.

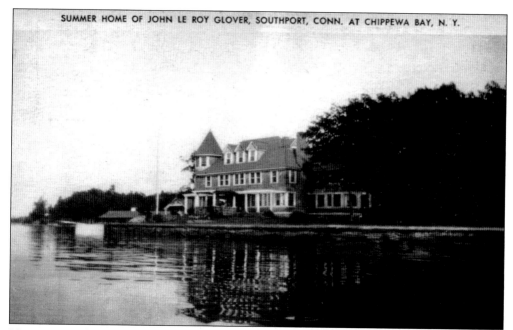

Not everyone built summer homes in the core area of the Thousand Islands between Clayton and Alexandria Bay on the New York side and Gananoque and Rockport on the Ontario side. For some, Chippewa Bay was (and still is) a quieter, more remote alternative to the nonstop activity upriver.

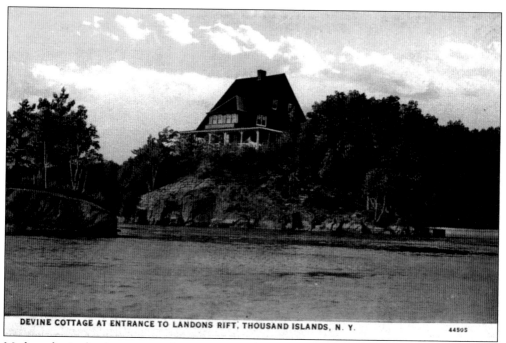

DEVINE COTTAGE AT ENTRANCE TO LANDONS RIFT, THOUSAND ISLANDS, N. Y.     44505

Madawaska Lodge looms over the entrance to the Out of Sight Channel just upriver from the Canadian span. As on this card, it is sometimes referred to as Landon's Rift.

61

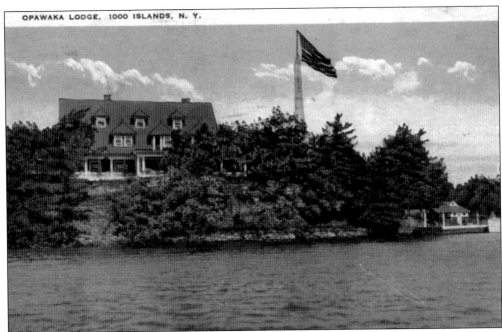

Opawaka Lodge is frequently called the House of Seven Gables, even though the window extensions on the front roof are not gables at all. The main structure is one of several cottages, outbuildings, and boathouses that occupy Dashwood Island (also known as Hines Island) between Ivy Lea and Hill Island.

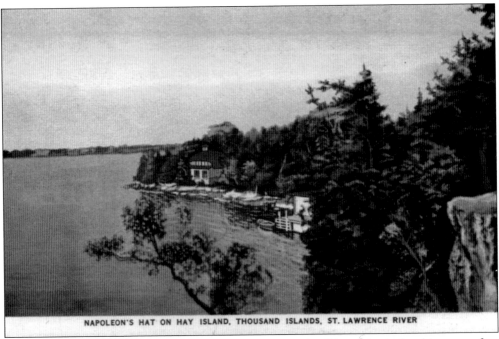

NAPOLEON'S HAT ON HAY ISLAND, THOUSAND ISLANDS, ST. LAWRENCE RIVER

Napoleon's Hat on Hay Island near Gananoque is an example of the whimsical architecture often found in the islands. Gingerbread trim abounds in Thousand Island Park, the former Methodist camp-turned-summer cottage community at the head of Wellesley Island.

## Four

# HOTELS AND RESORTS

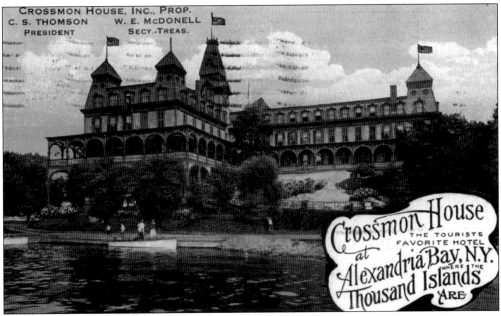

The Gilded Age of the grand hotels in the Thousand Islands lasted from about 1880 to 1925. Most visitors arrived in style via the New York Central Railroad and then took steamships to their island destinations. The advent of the automobile as a conveyance for almost everyone, not just the wealthy, was the principal reason for the demise of these wonderful hotels and resorts. Pictured here is one of the premier facilities, the Crossmon House in Alexandria Bay about 1928.

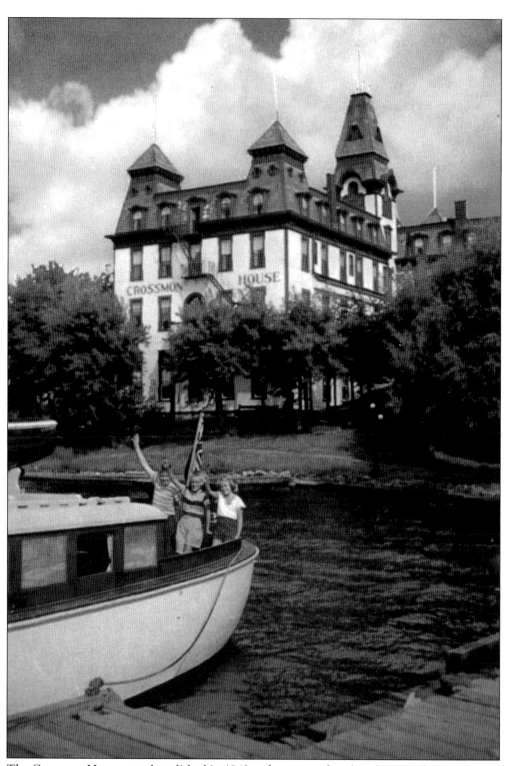

The Crossmon House was demolished in 1962, a few years after this photograph was taken. It was the last of the old resort hotels to receive a visit from the wrecker's ball.

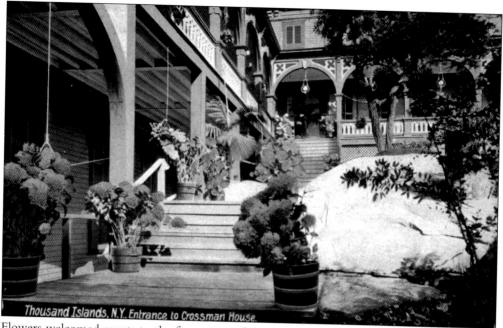

Flowers welcomed guests to the front steps of the Crossmon House. Capt. Thomson's Motor Lodge now occupies the site.

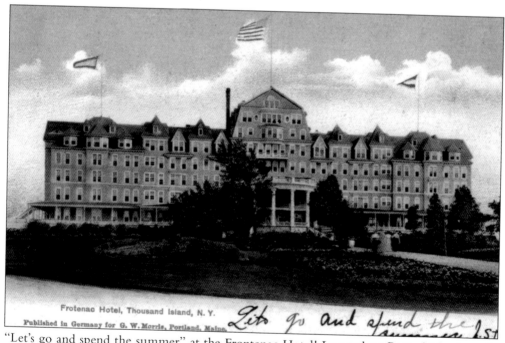

"Let's go and spend the summer" at the Frontenac Hotel! Located on Round Island a mile downriver from Clayton, the Frontenac Hotel was the largest and grandest of the region's summer resorts. It was enlarged and modified in 1890 to its distinct later appearance, as shown in this view.

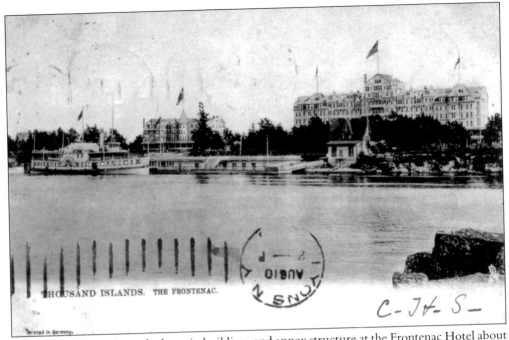

This card shows the huge dock, main building, and annex structure at the Frontenac Hotel about 1905, with the steamer *St. Lawrence* delivering another load of guests.

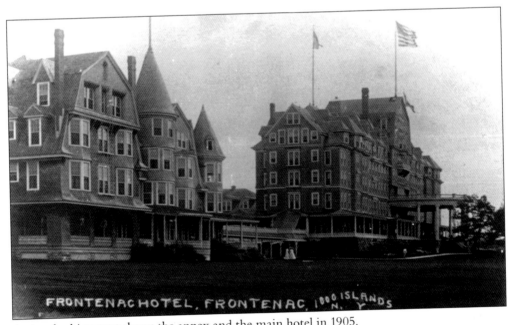

A view looking west shows the annex and the main hotel in 1905.

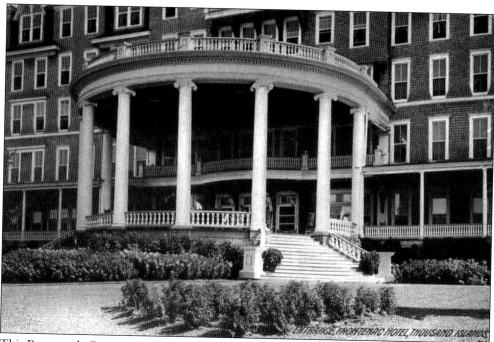

This Rotograph Company postcard, produced in Germany around 1908, shows a close-up of the main entrance to the hotel.

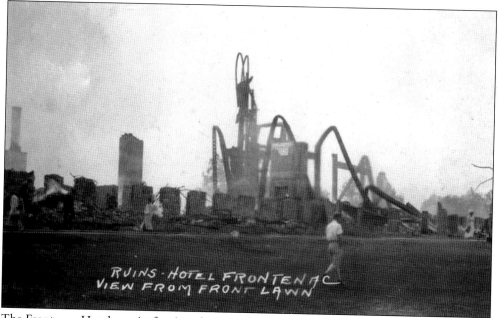

The Frontenac Hotel met its fate in a devastating fire in the early summer of 1911.

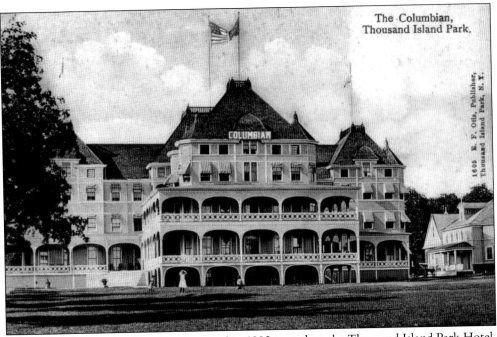

The magnificent Columbian Hotel opened in 1892 to replace the Thousand Island Park Hotel, which was the center of life "on the Park" from 1883 to 1890.

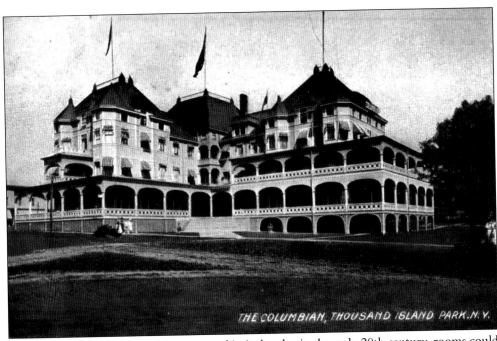

The Columbian Hotel had 200 rooms, and in its heyday in the early 20th century, rooms could be had for $3 per day. This is another German postcard from about 1909.

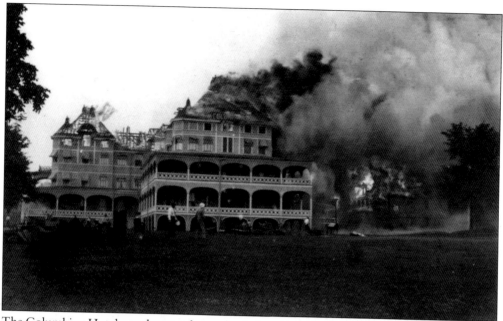

The Columbian Hotel was destroyed completely in a devastating fire on July 9, 1912. More than 100 of the cottages immediately to its east were consumed in the blaze.

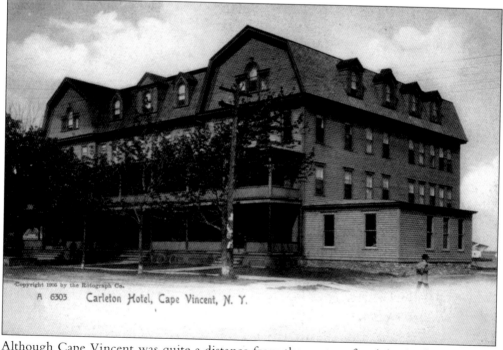

Copyright 1906 by the Rotograph Co.
A 6303    Carleton Hotel, Cape Vincent, N. Y.

Although Cape Vincent was quite a distance from the center of activity in the Thousand Islands, the community and its surroundings did appeal to discerning visitors and had hotels to accommodate them. This is the Carleton Hotel about 1909.

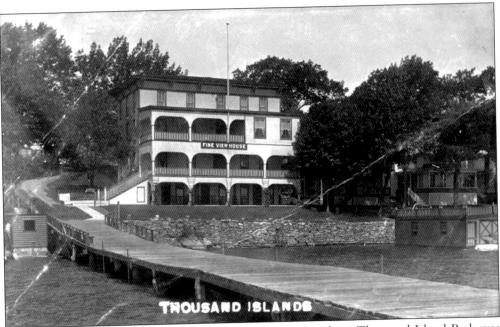

The Fine View House on Wellesley Island just downriver from Thousand Island Park was destroyed by fire in 1914.

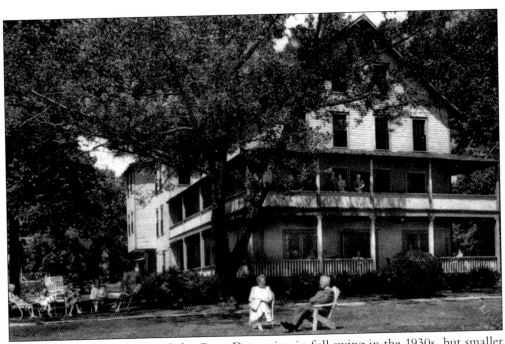

The Gilded Age was gone and the Great Depression in full swing in the 1930s, but smaller hotels like Geneva-by-the-River in Thousand Island Park still drew clientele for relaxation and recreation.

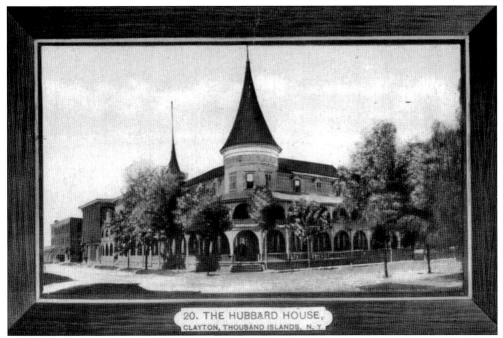

This card shows the Hubbard House annex on the corner of James and Hugunin Streets in Clayton. The original frame Hubbard House opened in 1850 and burned in 1895.

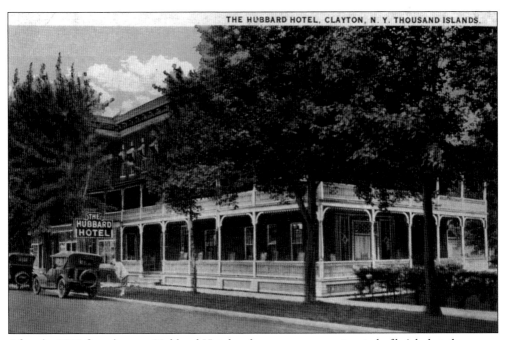

After the 1895 fire, the new Hubbard Hotel and annex were constructed of brick, but the annex nevertheless burned in 1909. This card provides another view of the Hubbard Hotel, this time about 1920.

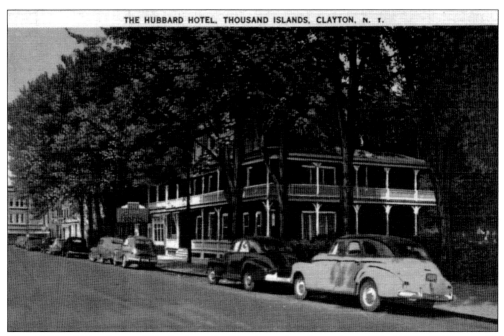

The Hubbard Hotel was still in business in this view taken just prior to World War II. Bertrand's Motel now occupies the site.

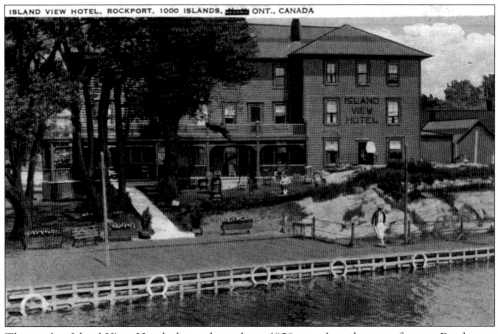

The modest Island View Hotel, shown here about 1920, stood on the waterfront at Rockport, a small community downriver from the Canadian span of the Thousand Islands Bridge. A restaurant and souvenir stand now occupy the site.

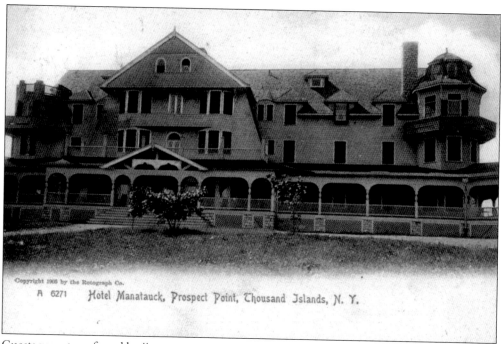

A 6271    Hotel Manatauck, Prospect Point, Thousand Islands, N. Y.

Guests were transferred by jitney or water taxi from the waterfront railroad depot at Clayton to the Hotel Manatauck across French Bay on Prospect (now Bartlett) Point.

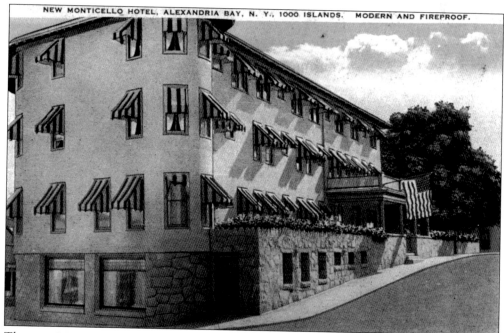

NEW MONTICELLO HOTEL, ALEXANDRIA BAY, N. Y., 1000 ISLANDS.    MODERN AND FIREPROOF.

The new Monticello Hotel still stands in Alexandria Bay, but it has not accepted overnight guests for over 40 years.

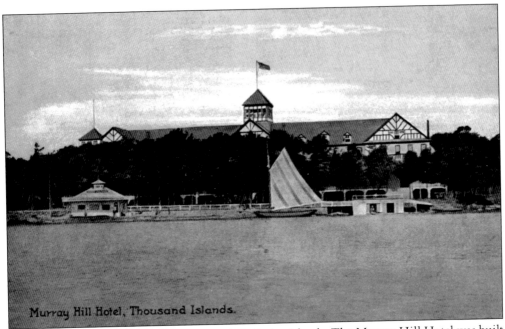

Murray Hill Hotel, Thousand Islands.

Murray Island lies between Grindstone and Wellesley Islands. The Murray Hill Hotel was built in 1895 at a cost of $100,000. Like every other Thousand Island resort, its season was short—May to September. The hotel lasted 20 seasons; in August 1915, it closed down for good.

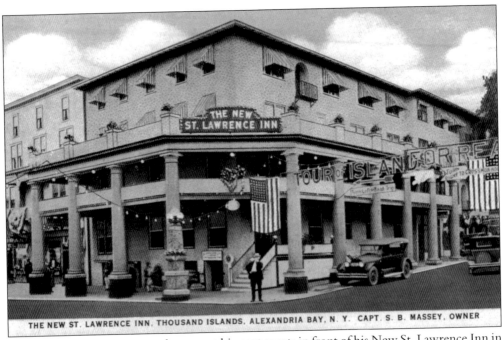

THE NEW ST. LAWRENCE INN, THOUSAND ISLANDS, ALEXANDRIA BAY, N. Y. CAPT. S. B. MASSEY, OWNER

Capt. S. B. Massey appears ready to greet his next guests in front of his New St. Lawrence Inn in downtown Alexandria Bay about 1920. Once checked in, guests could walk around the corner and take a ride on one of his sightseeing boats.

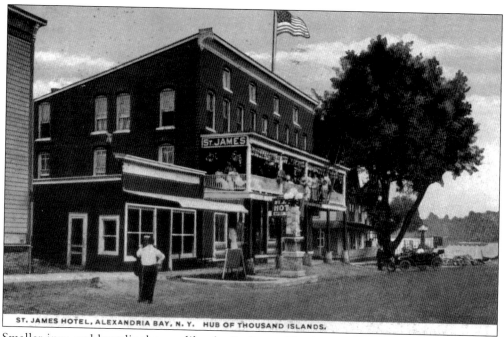

ST. JAMES HOTEL, ALEXANDRIA BAY, N. Y.   HUB OF THOUSAND ISLANDS.

Smaller inns and boardinghouses like the St. James Hotel in Alexandria Bay catered to the decidedly less-wealthy tourists. This Santway Company postcard was published in little Star Lake, New York, around 1920.

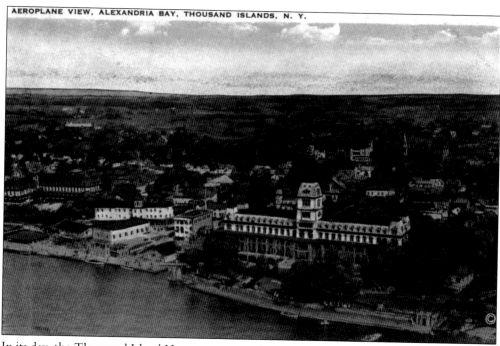

AEROPLANE VIEW, ALEXANDRIA BAY, THOUSAND ISLANDS, N. Y.

In its day, the Thousand Island House was a premier resort property. It opened in 1873 and was razed in 1937. From its perch on the Alexandria Bay waterfront, it offered guests magnificent views of Boldt Castle and Millionaire's Row across the river.

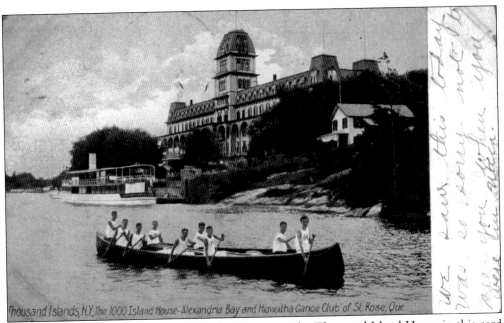

Canoe races must have been one of the day's events at the Thousand Island House in this card published about 1906.

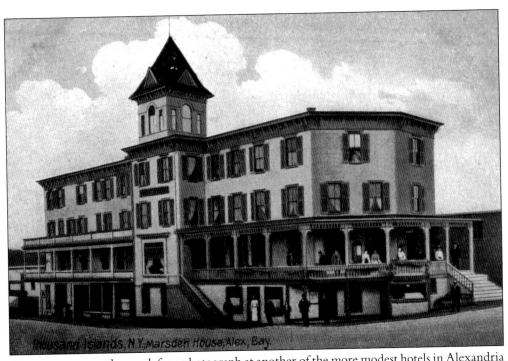

Guests turn out on the porch for a photograph at another of the more modest hotels in Alexandria Bay, the Marsden House, about 1912.

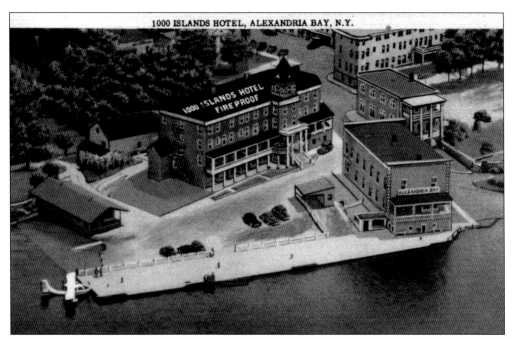

Originally called the Marsden House, the 1000 Islands Hotel used this card for a not-so-subtle advertising message to lure tourists to its property on Market Street in "the Bay," as Alexandria Bay is commonly called. The main wharf and Cornwall Brothers store are in the foreground of this card from the 1940s.

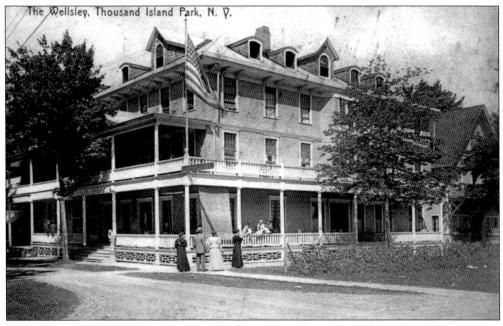

Limited accommodations, a restaurant, and several boutiques are still at the Wellesley Hotel on the four corners in Thousand Island Park. The building looks the same, but the dress and street scene are significantly different now from when this photograph was taken about 1910.

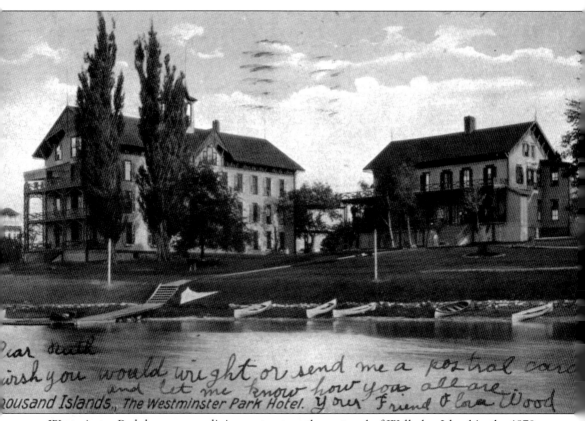

Westminster Park began as a religious retreat on the east end of Wellesley Island in the 1870s. Guests for the small hotel arrived from Alexandria Bay by ferry, which docked in a slip built on the eastern side of the island.

*Five*

# TOWNS AND VILLAGES

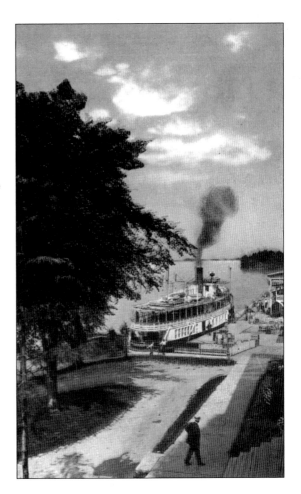

Alexandria Bay was named for a daughter of James LeRay de Chaumont, a famed French émigré who helped develop the North Country of New York State in the early 19th century. Like most of the river communities, the Bay was a sleepy outpost in northern New York until visitors and tourists arrived in the 1870s. Once millionaires like New York City hotel owner George C. Boldt became enamored by the river's beauty and built castles and mansions on neighboring islands, Alexandria Bay moved to prominence as the focal point of the Gilded Age in the Thousand Islands. The region retains some recognition in restaurants worldwide. In 1894, Boldt's personal chef created an unforgettable salad dressing that was introduced at the Waldorf Astoria in New York as "Thousand Islands Dressing."

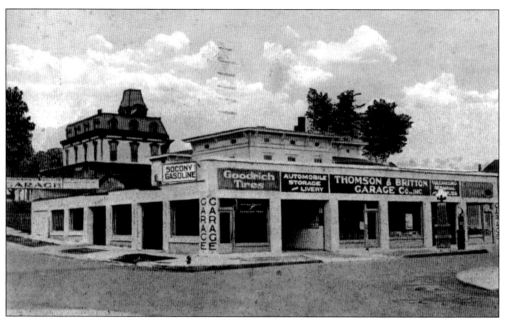

Thomson and Britton's garage occupied the northeast corner of Church and James Streets in Alexandria Bay for many years. A nightclub and several small shops now operate in this building.

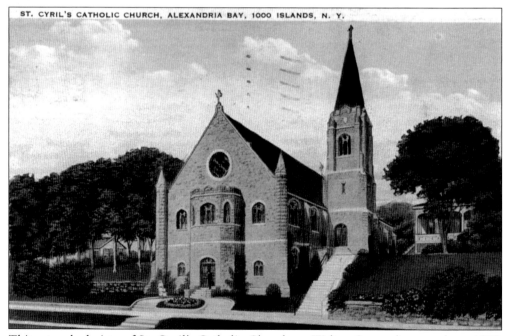

This retouched view of St. Cyril's Catholic Church on Walton Street dates to about 1929. Either the church or the publisher thought the spire on the tower should be added to the card. It was never built.

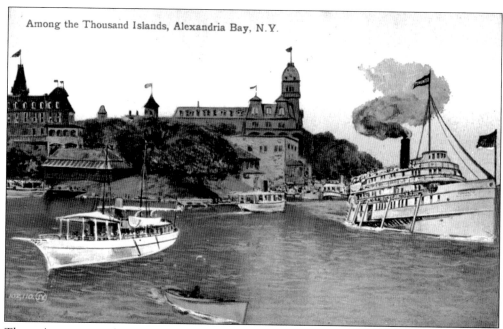

Among the Thousand Islands, Alexandria Bay, N.Y.

The artist got carried away in adding the number and variety of vessels to this waterfront view from about 1912. The Cornwall Brothers store and the Thousand Island House are in the middle background.

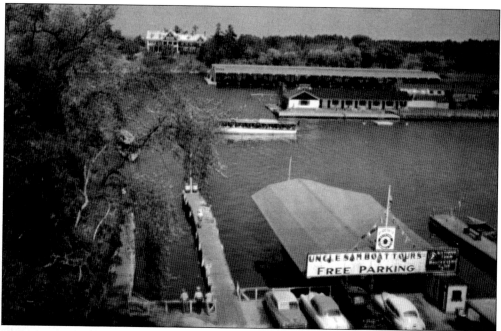

This photograph is of Lower James Bay in the early 1950s. Boat tours of the islands and Boldt Castle still leave from the docks in the foreground. In the upper center right is the old Riveredge Motel, which burned down in the late 1980s and was replaced by a much larger, modern facility. Bonnie Castle sits on the bluff across the bay.

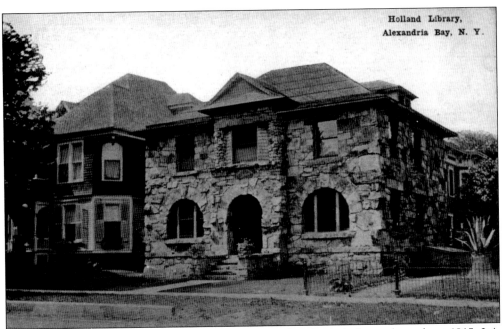

Built with native granite, the Holland Library on Market Street is shown here about 1915. It is on the National Register of Historic Places.

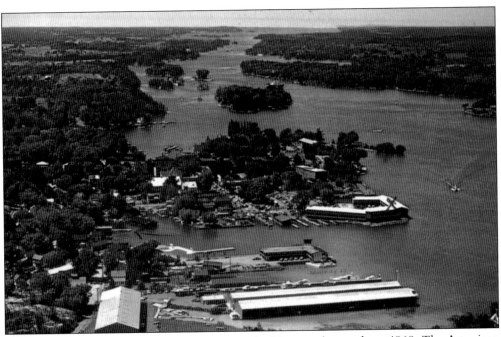

This card presents a bird's-eye view of the Bay looking southwest about 1968. The American span of the Thousand Islands Bridge is visible in the background.

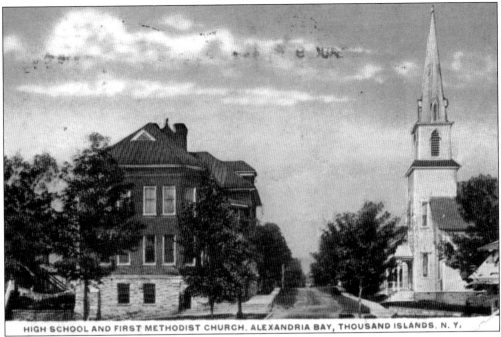

HIGH SCHOOL AND FIRST METHODIST CHURCH. ALEXANDRIA BAY, THOUSAND ISLANDS, N. Y.

This pre-1920 card shows the high school and First Methodist Church.

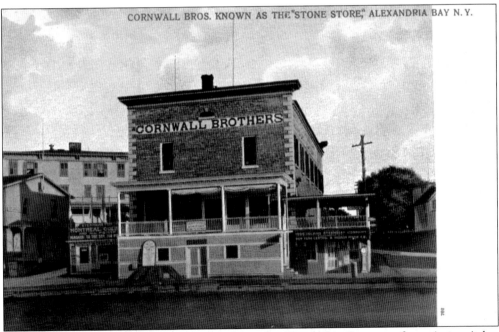

CORNWALL BROS. KNOWN AS THE "STONE STORE," ALEXANDRIA BAY N. Y.

The Cornwall Brothers store is a landmark on the Alexandria Bay waterfront, just as it has been for over 125 years. The wharf in front welcomed steamships from as far away as Toronto through World War II, but it collapsed some 50 years ago. The building is still in operation by the local historical society.

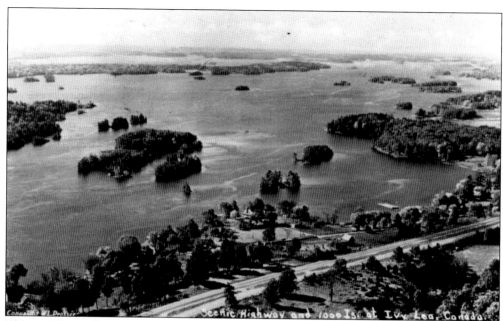

This aerial view looking southwest shows a portion of Highway 2 and the islands off Ivy Lea just after World War II. The highway along the river from Gananoque to Brockville is now designated the Thousand Islands Parkway.

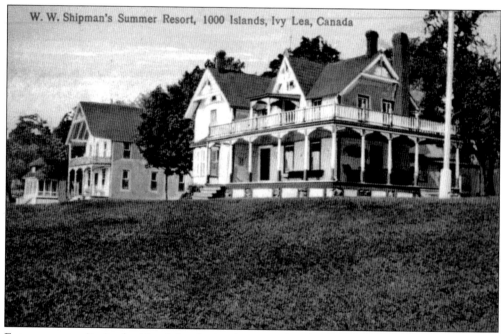

Every community in the islands has had at least one hotel, with some more modest than the others. The Shipman family's resort in Ivy Lea, seen here about 1912, catered to a different clientele than did the larger, more upscale hotels in Alexandria Bay or Gananoque.

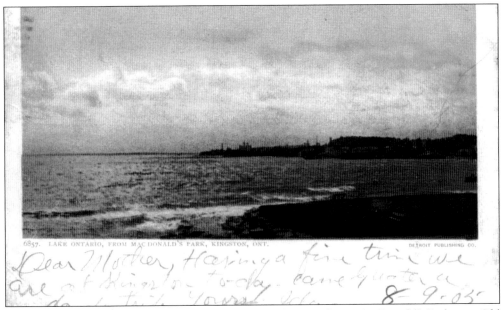

6857. LAKE ONTARIO, FROM MACDONALD'S PARK, KINGSTON, ONT.          DETROIT PUBLISHING CO.

This rare card views Kingston, its harbor, and Lake Ontario from MacDonald's Park near Old Fort Henry around 1905.

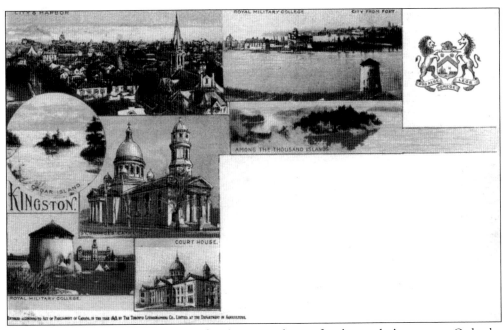

The blank space along the bottom of early postcards was for the sender's message. Only the address could be written on the back side of cards prior to 1907. This card's unusual format includes prominent Kingston sights.

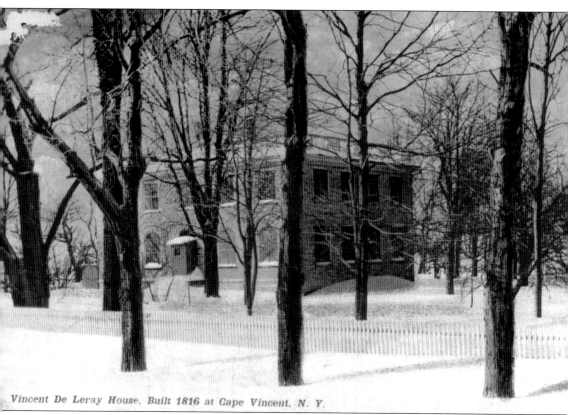

*Vincent De Leray House, Built 1816 at Cape Vincent, N. Y.*

Cape Vincent takes its name from a son of James LeRay de Chaumont, Vincent, who built a stately mansion on Broadway in 1816. Early industries here were lumbering, ice harvesting, hay, and seeds. By 1900, businesses included boatbuilders, feed dealers, photographers, monument salesmen, blacksmiths, milliners, tailors, and several livery stables. It also boasted an important railroad terminus.

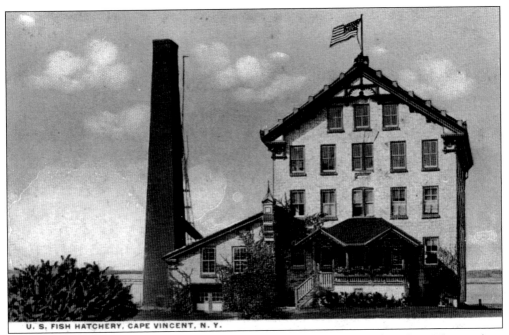

U. S. FISH HATCHERY, CAPE VINCENT, N. Y.

The fish hatchery building, viewed here about 1920, has been a landmark in Cape Vincent since the end of the Civil War. Its aquarium and exhibits have been entertaining visitors young and old for many decades.

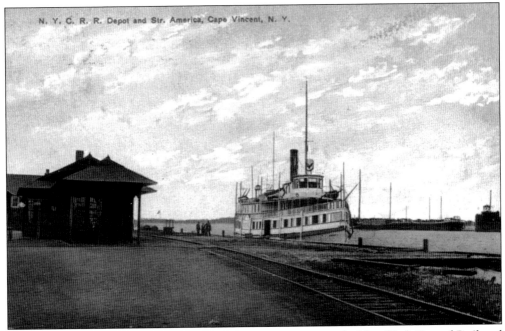

N. Y. C. R. R. Depot and Str. America, Cape Vincent, N. Y.

Cape Vincent (commonly called "the Cape") was a terminus on the New York Central Railroad system. The line connected at Watertown with the main northern line of the system and brought visitors to the Cape from all over the Northeast. Here the steamer *America* awaits the next train around 1910.

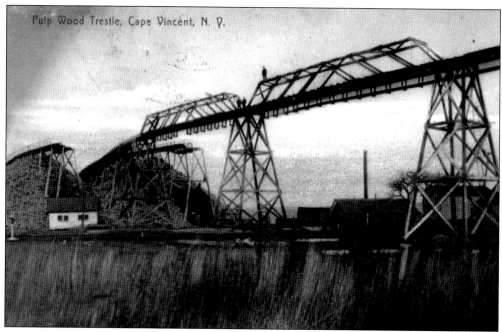

Cape Vincent supplied pulpwood from northern New York's forests to paper mills and other users around the Great Lakes and the St. Lawrence River. Brought by train to the village, it was loaded onto ships from this trestle.

This photograph from about 1908 shows one of the many large homes that face north along the riverfront in Cape Vincent.

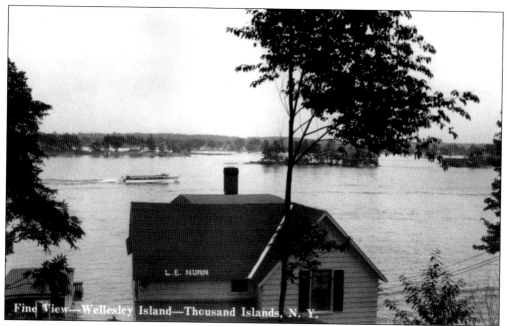

Fine View is a hamlet of mostly cottages on Wellesley Island just downriver from Thousand Island Park. This view from about 1950 looks across to Fishers Landing. The $5 Photo Company of Canton published this card.

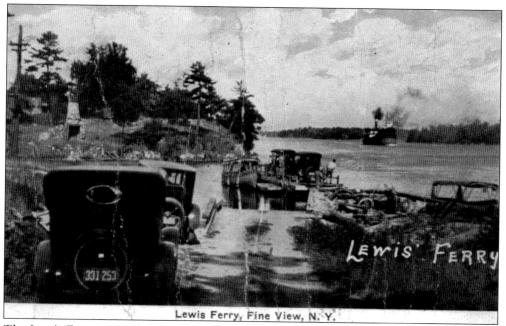

The Lewis Ferry crossed the American Narrows between Collins Landing and Wellesley Island before the Thousand Islands Bridge was completed directly above it in 1938. This view looks downriver from the Wellesley Island side. A coal-fired, pre-seaway canaller is headed upbound.

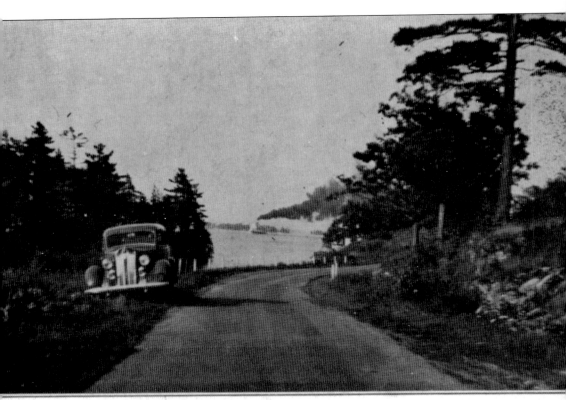

**Winding Road — Fine View, N. Y.**

This view looks southwest along Peel Dock Road on Wellesley Island near Fine View in the 1930s. Around the curve is Peel's Dock, where, 100 years earlier during the Patriot's War, Americans seized and burned the British steamship *Sir Robert Peel*. The Thousand Islands were a focal point in that conflict when attempts were made to invade Canada and wrest it from the British Empire.

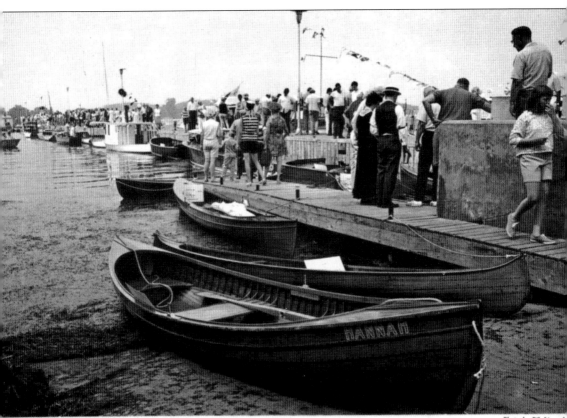

ntique Boat Show - Clayton, New York

Located in the geographical center of the Thousand Islands on a peninsula jutting out into the river, Clayton was originally known as Cornelia after a daughter of James LeRay de Chaumont. In the late 19th and early 20th centuries, Clayton was the terminus of an important spur line of the New York Central Railroad. Hundreds of thousands of visitors from all over the Northeast began their island visits here every summer. Now enjoying rejuvenation, Clayton is the home of the renowned Antique Boat Museum. Every August, thousands of boat lovers, exhibitors, and spectators converge on the museum for the Antique Boat Show and Auction. Established in 1964, it is the oldest event of its kind in North America.

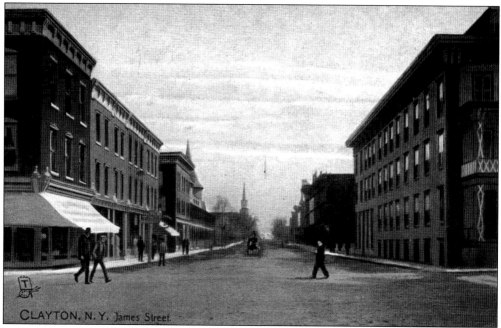

Raphael Tuck and Sons, "Art Publishers to their Majesties the King and Queen of England," produced this card of James Street about 1908.

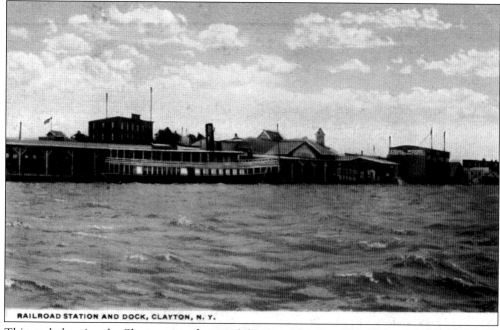

This card, showing the Clayton waterfront and the covered railroad depot, is a Santway Company postcard, published in Star Lake around 1920. Frink Park and the municipal docks are now located along this stretch of the waterfront.

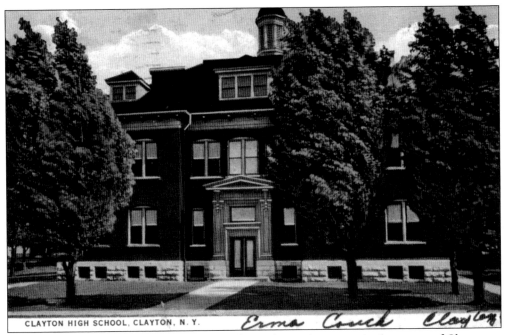

CLAYTON HIGH SCHOOL, CLAYTON, N. Y.

The old Clayton High School building was located near the square in the center of Clayton.

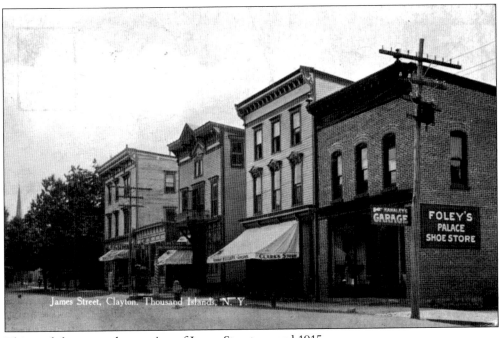

James Street, Clayton. Thousand Islands, N. Y.

This card shows another section of James Street around 1915.

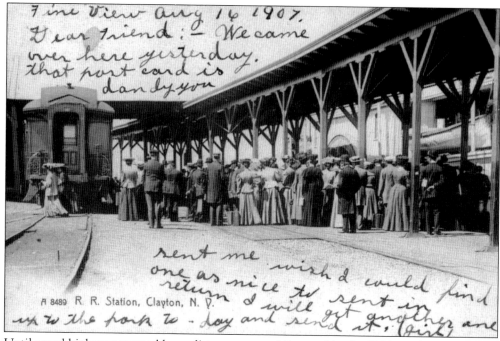

Fine View Aug 16 1907.
Dear friend :— We came
over here yesterday.
that post card is
dandy you

sent me
one as nice
return
up to the park to - day and send it. *(girl)*

A 8489  R. R. Station, Clayton, N. Y.

Until paved highways spurred long-distance automobile travel in the 1920s, railroads were the preferred means of transportation for visitors to arrive at Clayton and the Thousand Islands since the 1880s. Here passengers wait to board the *St. Lawrence* at the dock that is now Frink Park.

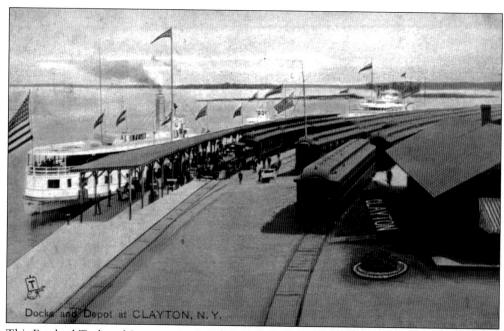

Docks and Depot at CLAYTON, N. Y.

This Raphael Tuck and Sons postcard shows another view of the depot, looking northeast with Round Island in the distance. More than a dozen trains arrived and departed at Clayton every day during the heyday of the grand hotels.

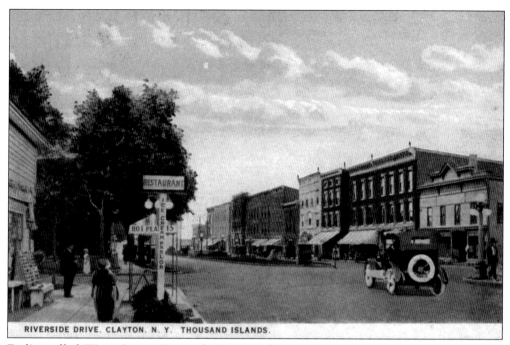

RIVERSIDE DRIVE, CLAYTON, N. Y. THOUSAND ISLANDS.

Earlier called Water Street, Riverside Drive is the main business section along the river in downtown Clayton.

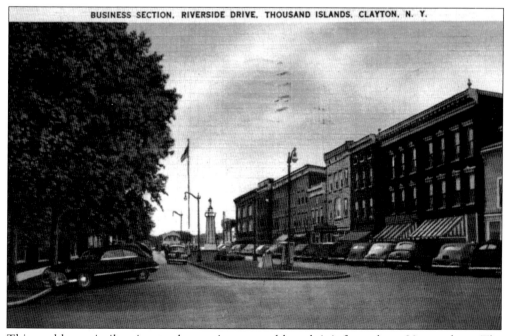

BUSINESS SECTION, RIVERSIDE DRIVE, THOUSAND ISLANDS, CLAYTON, N. Y.

This card has a similar view to the previous one, although it is from about 20 years later. The center median and its monuments are now gone.

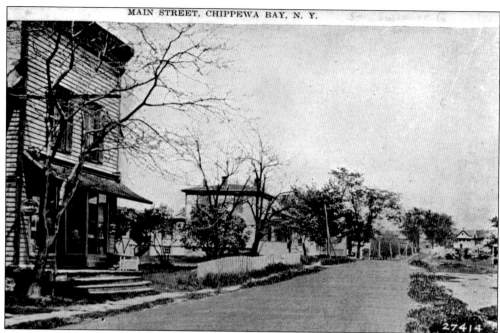

Chippewa Bay is dotted with islands of all sizes and is the namesake for the quiet village about halfway between Alexandria Bay and Morristown. This William Jubb and Company postcard, published in Syracuse, shows the general store on the left and residences in the center and to the right. (Fred H. Rollins collection.)

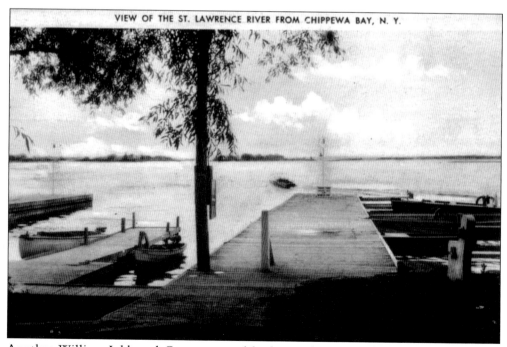

Another William Jubb and Company card looks north across Chippewa Bay from the municipal docks.

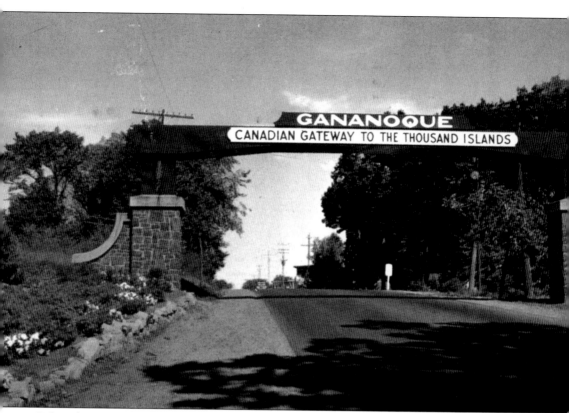

Col. Joel Stone, who served with loyalist militia during the American Revolution, established a settlement on the Gananoque River in 1789. Land was granted to Stone for use as a mill site. During the War of 1812, American forces raided the government depot in the town to disrupt the flow of British supplies between Kingston and Montreal. The stores seized consisted of half an ox, a few straw ticks, and blankets. Today Gananoque, or "Gan," is a major tourist destination, and the sign above its western entrance still proclaims it the "Canadian Gateway to the Thousand Islands." Similar signs on the U.S. side do not bother to properly define them as the "American gateway."

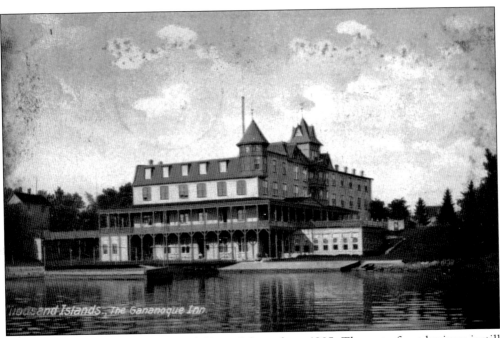

The Gananoque Inn is the subject of this card from about 1905. The waterfront business is still in operation just east of where the Gananoque River meets the St. Lawrence River.

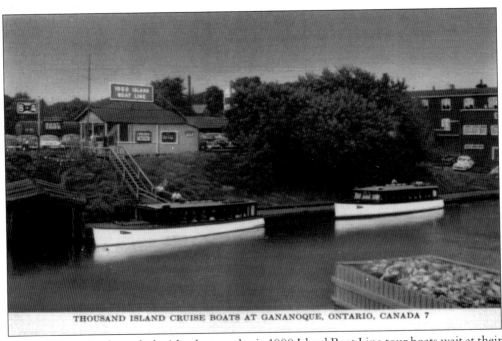

THOUSAND ISLAND CRUISE BOATS AT GANANOQUE, ONTARIO, CANADA 7

Ready for a cruise through the islands, two classic 1000 Island Boat Line tour boats wait at their dock in the Gananoque River around 1940. Access to this area by today's larger tour boats is blocked by a lift bridge to the right (not pictured) that no longer operates.

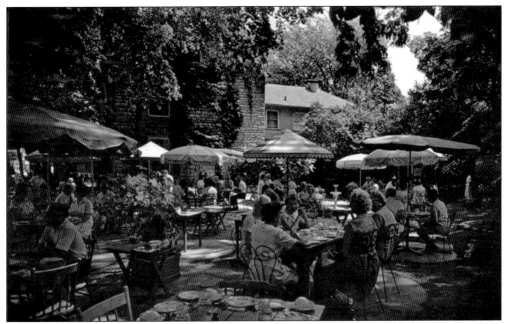

The Golden Apple restaurant with its garden terrace remains a popular Gananoque eatery decades after this 1960s photograph was taken.

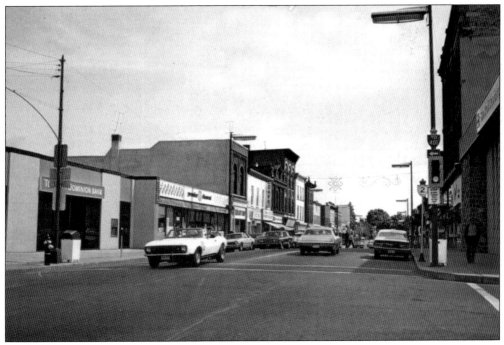

The central business section of Gananoque at the corner of King and Stone Streets is the subject of this 1970s color card. At the time, there were three major banks at the intersection, one on each corner, with the fourth corner occupied by the Provincial Inn.

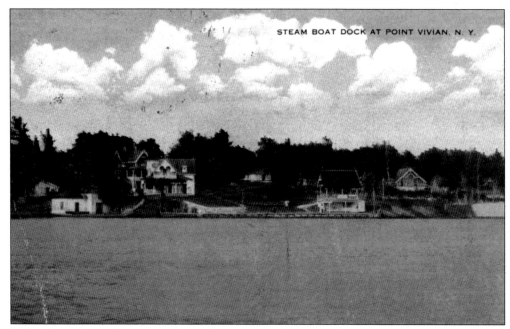

Point Vivian is on the New York mainland midway between the Thousand Islands Bridge and Alexandria Bay. This view from Wellesley Island has changed little since the card was published around 1915.

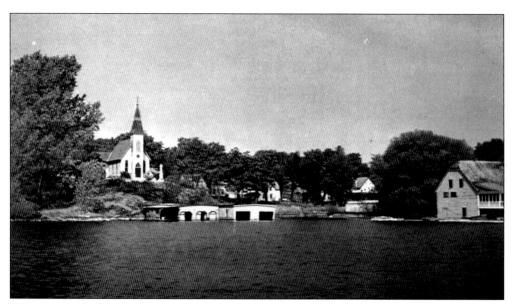

A Roman Catholic church overlooks the picturesque cove at Rockport on the Ontario mainland a few miles downriver from the Canadian span of the Thousand Islands Bridge.

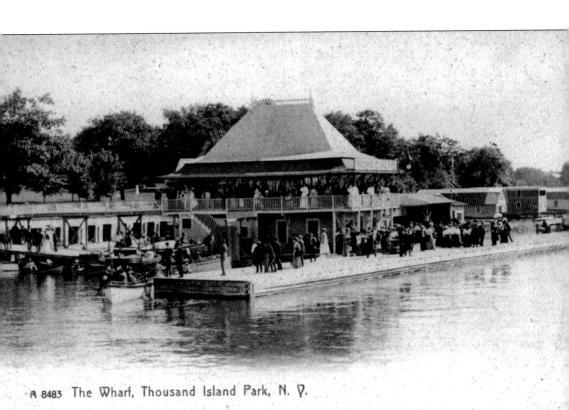

A 8483 The Wharf, Thousand Island Park, N. Y.

In 1874, Methodists purchased 1,000 acres on the southwest end of Wellesley Island and began a summer religious retreat called Thousand Island Park. By the dawn of the 20th century, cottages had replaced tents, and Thousand Island Park boasted one of the finest hotels in the area. The main wharf (with the building now called the pavilion) is bustling with activity in this photograph from about 1905.

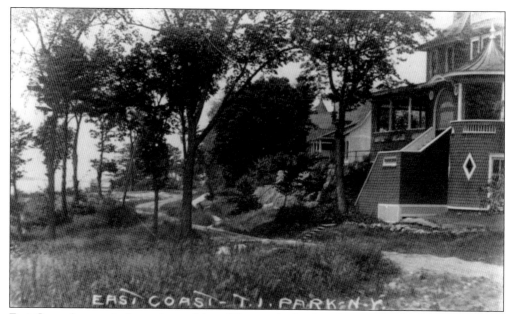

East Coast Avenue is the main road into Thousand Island Park on Wellesley Island. Today it is wider and a bit straighter than it was in this 1905 photograph. The cottage to the right is Ledgecrest, the onetime summer home of Bronson A. Quackenbush.

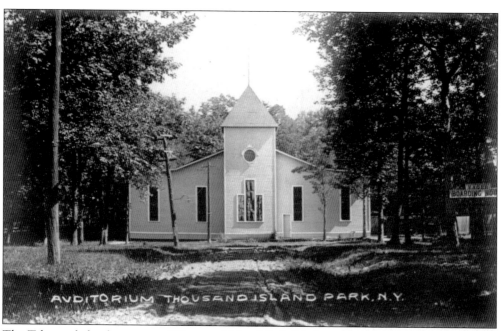

The Tabernacle has been part of Thousand Island Park life for well over 100 years. For a short time, it was called the Auditorium. To this day, it is used in the summer months as an open-air movie theater, house of worship, and social gathering spot.

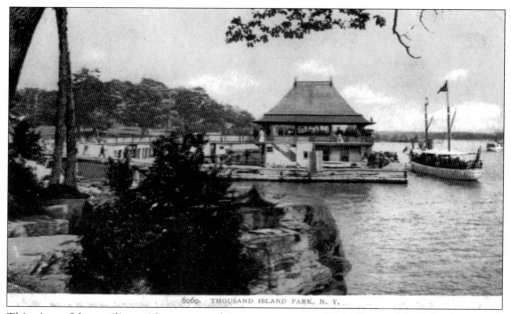

This view of the pavilion with an approaching steamer was published around 1902 by the Detroit Photographic Company, inarguably the most outstanding American publisher of postcards in the early 20th century.

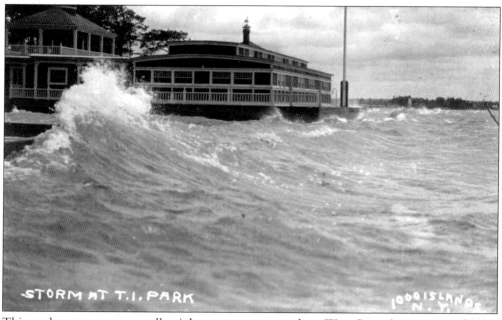

This card captures an unusually violent summer storm along West Coast Avenue around 1912.

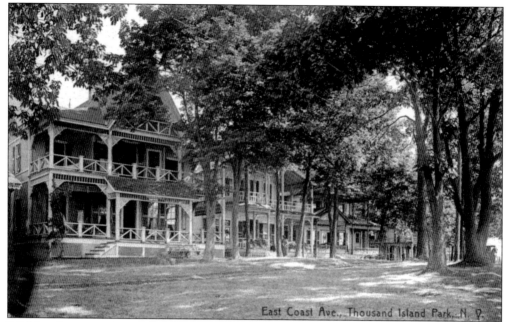

Within a few years of this photograph, only the cottage on the extreme left remained. The others and more behind them were caught up in the Columbian Hotel fire in July 1912. Now called the House Next Door, the surviving cottage was protected by the metal-sheathed Iron Cottage (not pictured, immediately to the left), which stood between it and the hotel inferno.

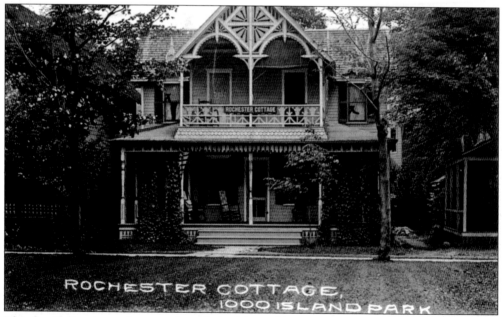

This fancifully trimmed cottage is typical of the architecture that dominates Thousand Island Park. This particular one was part of the complex of cottages that operated as the Rochester Hotel. They are now all privately owned.

*Six*

# BRIDGES AND
# LIGHTHOUSES

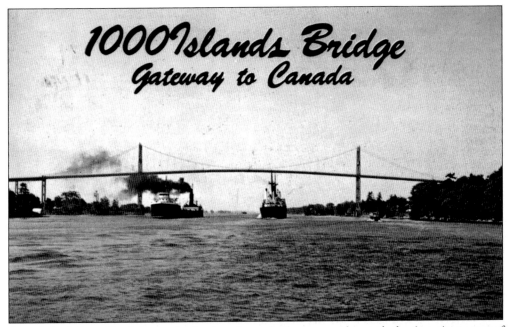

A coal-fired Canadian laker and a foreign-flagged salty pass underneath the American span of the Thousand Islands Bridge in a photograph looking southwest in the early 1960s. Known in the region as simply "the bridge," it is actually a system of five bridges and interconnecting roadways that skip across the St. Lawrence River between Collins Landing in New York and Ivy Lea in Ontario. Antique postcards of the Thousand Islands Bridge system do not exist. The bridge was completed in 1938.

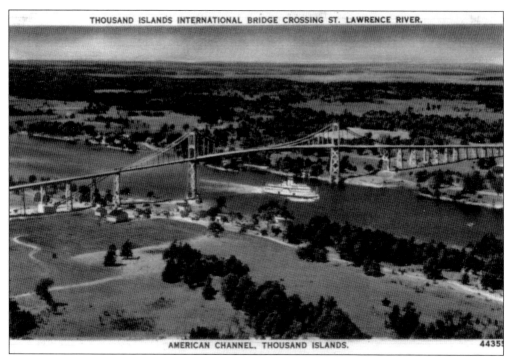

THOUSAND ISLANDS INTERNATIONAL BRIDGE CROSSING ST. LAWRENCE RIVER.

AMERICAN CHANNEL, THOUSAND ISLANDS.                    4435

CSL and its early predecessor companies operated passenger service up and down the St. Lawrence River for over 70 years before the automobile rendered their operations uneconomical in the 1950s. Here the CSL steamer *Kingston* heads downriver underneath the American span.

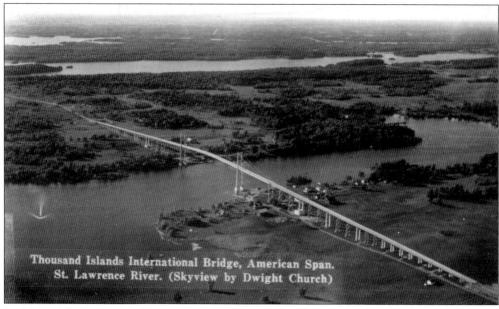

Thousand Islands International Bridge, American Span. St. Lawrence River. (Skyview by Dwight Church)

In this aerial photograph from the 1940s, the American span crosses the American Narrows, linking the New York mainland (lower right) with Wellesley Island. Lake of the Isles stretches across the middle background, and the Canadian Middle Channel and mainland Ontario are visible in the far background.

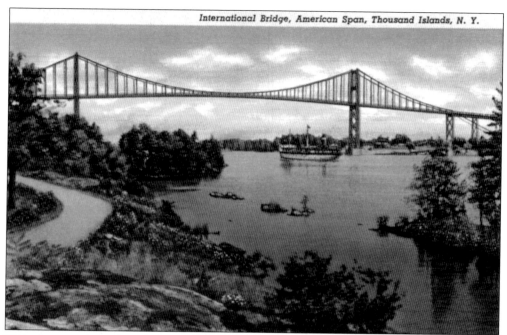

With the exception of a wider road and larger ships, this view from Peel Dock Road on Wellesley Island has changed very little since this card was published just before World War II. This is one of several different cards depicting this scene, all taken from a rise in the road near Peel's Dock and the site of the looting and burning of the *Sir Robert Peel* in 1838.

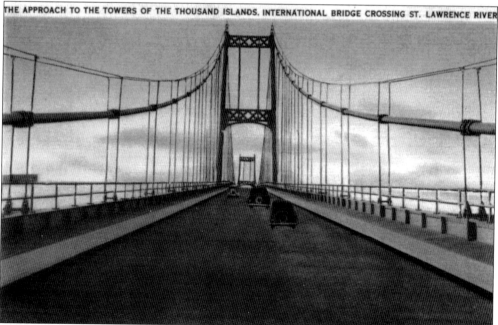

THE APPROACH TO THE TOWERS OF THE THOUSAND ISLANDS. INTERNATIONAL BRIDGE CROSSING ST. LAWRENCE RIVER

In another example of postcard exaggeration, the publisher's attempt to enhance the scene by adding cars backfired when the wrong scale was used. The cars are woefully undersized compared to the width of the roadway. Taking this shot today would be dangerous given the vastly increased truck traffic on the bridge.

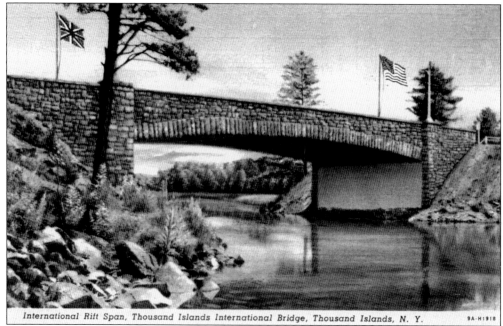

International Rift Span, Thousand Islands International Bridge, Thousand Islands, N. Y.    9A-H1918

Often dubbed the "shortest international vehicular bridge in the world," the span over the International Rift between Wellesley and Hill Islands was twinned in the 1960s, and two nearly identical concrete and granite bridges now cross the rift. Note the British Union Jack on the left (Canadian) side of the bridge.

The Canadian customs facility on Hill Island awaits vehicles crossing the International Rift span from New York in the 1940s. This scene changed little until the 1970s when traffic grew rapidly after the completion of Interstate 81 in New York and Highway 401 in Ontario. Today the customs facilities on both sides of the border have undergone dramatic expansions. Hill Island in particular has seen an influx of commercial and tourist operations that line either side of the road near the customs facilities.

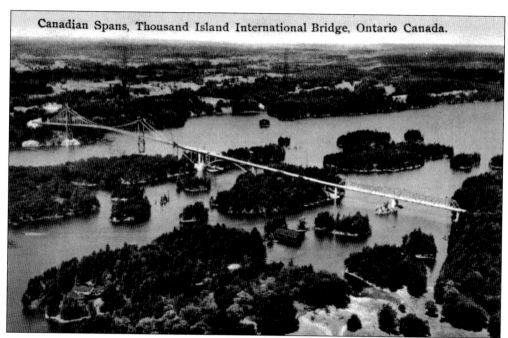

**Canadian Spans, Thousand Island International Bridge, Ontario Canada.**

The Canadian bridge comprises three distinctly different types of bridges—a Warren truss, an arch, and a suspension span that are joined end to end to allow one to hop from Hill Island in the right foreground to the Ontario mainland in the upper left.

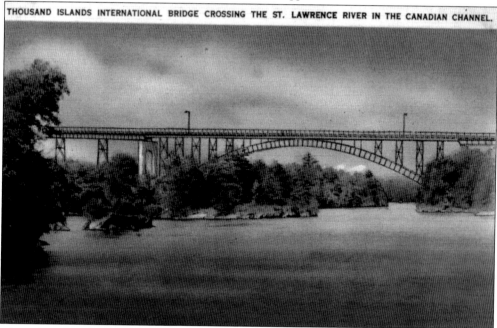

**THOUSAND ISLANDS INTERNATIONAL BRIDGE CROSSING THE ST. LAWRENCE RIVER IN THE CANADIAN CHANNEL.**

The arch span crosses the Lost Channel between Constance and Georgina Islands. An engineering marvel at the time of its completion in 1938, the massive concrete base of the tower at the left end of the arch serves three purposes: it is the skewback for the arch, the support for the roadway directly above it, and the anchor block for the cables of the suspension span (out of the image to the left).

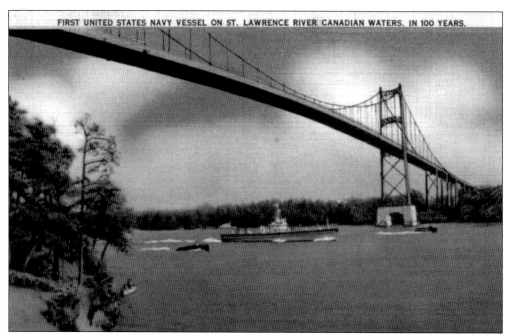

The Canadian suspension span crosses the channel from Georgina Island to the Ontario mainland near Ivy Lea. Although identical in design to its American counterpart, it is about 20 feet closer to the river's surface. The large ships in the St. Lawrence Seaway pass under the American span, which provides 150 feet of clearance over the water.

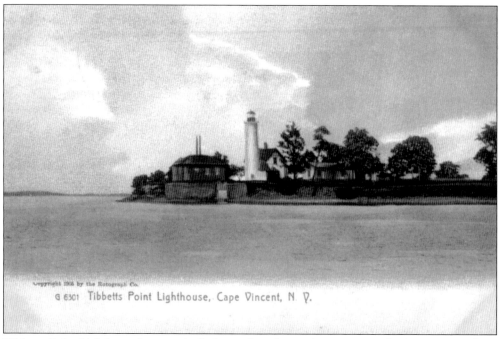

Copyright 1906 by the Rotograph Co.

G 6301 Tibbetts Point Lighthouse, Cape Vincent, N. Y.

Tibbetts Point Lighthouse is strategically located on the northeast corner of Lake Ontario where it becomes the St. Lawrence River. The lighthouse, the second on the site, was built in 1859. Its light still reaches out across the lake to guide today's ship traffic on the seaway.

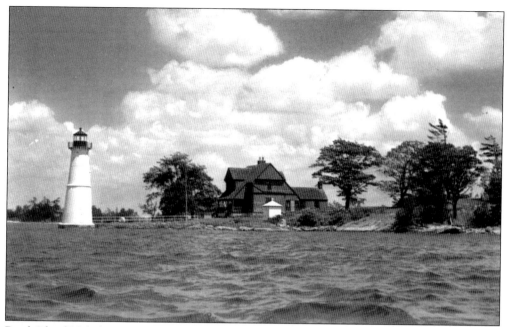

Rock Island Light between Fishers Landing and Thousand Island Park was originally constructed in 1882 in the middle of the island. It was later moved to the end of a pier jutting out into the shipping channel, where it still provides safe passage through a particularly narrow section of the seaway channel.

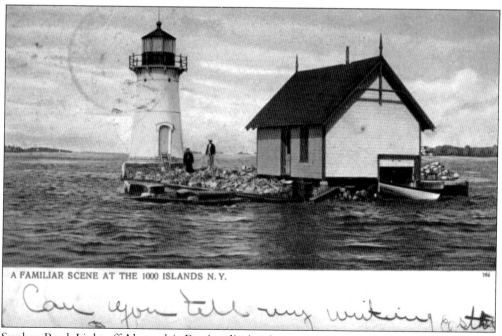

A FAMILIAR SCENE AT THE 1000 ISLANDS N.Y.

Sunken Rock Light off Alexandria Bay is a diminutive, younger sister of Rock Island Light near Fishers Landing. Built two years later and about 30 feet shorter but with an identical top, Sunken Rock and its sister continue to mark the south side of American Narrows ship channel.

Another mislabeled card shows an American tour boat passing Lyndoch Light at the west end of Fiddler's Elbow. The wood-framed lighthouse is typical of the dozen or more government-maintained markers along the Canadian Middle Channel that were upgraded to steel structures in the 1970s.

*Seven*

# BOATS AND SHIPS

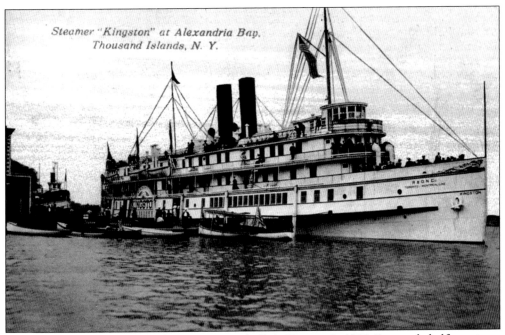

The steam-powered side-wheeler *Kingston* was built in Toronto in 1901. For nearly half a century, she stopped at Alexandria Bay every other day on her usual route between Toronto and Prescott, Ontario, where passengers transferred to smaller ships for the run through the rapids and canals down to Montreal and Quebec City. The *Kingston* was retired in 1949, just a few years before all passenger steamship service on the St. Lawrence River was discontinued.

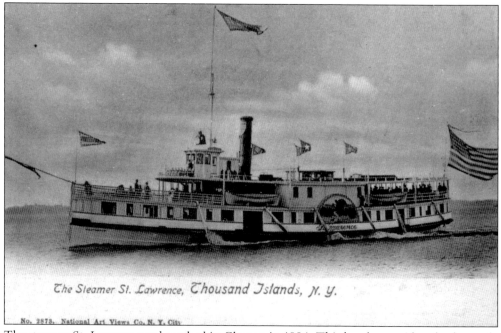

The steamer *St. Lawrence* was launched in Clayton in 1884. This handsome side-wheeler made regular excursions throughout the islands and delivered passengers and their luggage to all the resorts and island communities. Her sailing days ended under the scrap-cutter's torch in 1925.

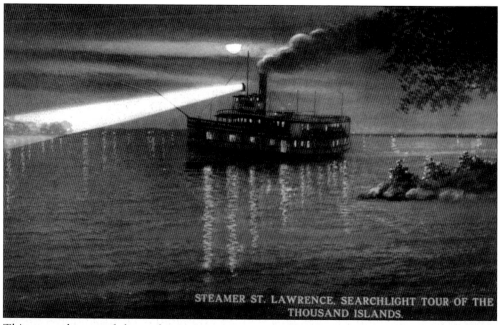

This unusual postcard shows the *St. Lawrence* on one of her famous searchlight cruises through the islands. This was a very popular tour for the passengers, but the inhabitants of the illuminated summer cottages were not so happy.

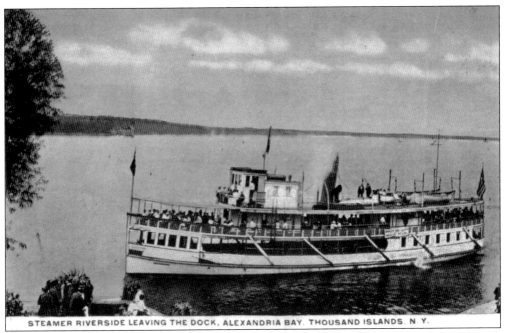

STEAMER RIVERSIDE LEAVING THE DOCK, ALEXANDRIA BAY, THOUSAND ISLANDS, N Y.

Looking north from the grounds of the Thousand Island House, this card shows the *Riverside* departing Alexandria Bay's main wharf with a load of sightseers out for an island tour. The *Riverside* was built in Buffalo in 1892 and retired from service in the late 1920s.

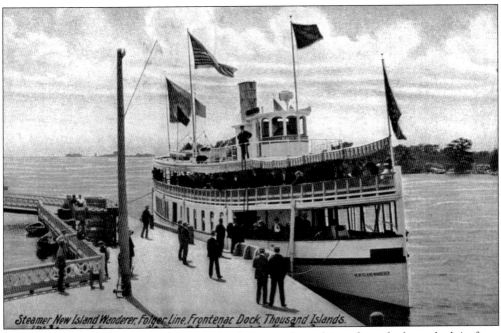

Steamer New Island Wanderer, Folger Line, Frontenac Dock, Thousand Islands.

The popular steamer *New Island Wanderer* is shown ready to depart from the huge dock in front of the Frontenac Hotel on Round Island. The vessel was built in Buffalo in 1888.

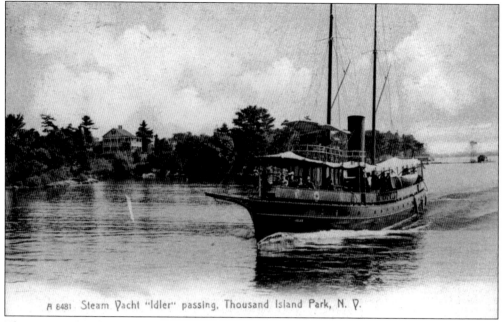

A 8481 Steam Yacht "Idler" passing, Thousand Island Park, N. Y.

The steam yacht *Idler* is shown approaching Thousand Island Park around 1910. Goose Island is to the left, and the Fine View Dock, now nothing but underwater cribs, is behind to the right.

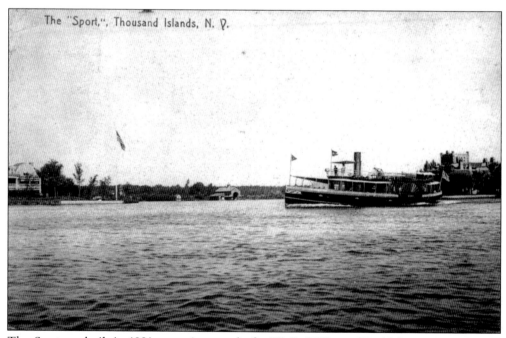

The "Sport,", Thousand Islands, N. Y.

The *Sport* was built in 1881 as a private yacht for W. E. Wilbur of Bethlehem, Pennsylvania, and Sport Island (see pages 21 and 60). The *Sport* was unique as she was a side-wheeler with a distinctive black hull and polished mahogany upper works.

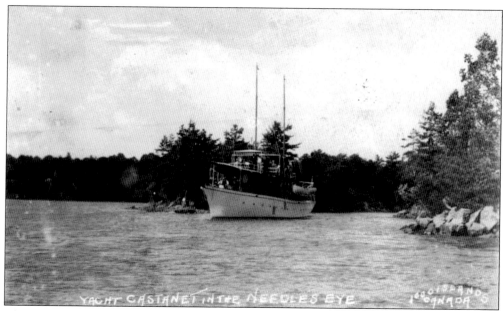

The yacht *Castanet* was launched at Alexandria Bay in 1898. For many years, she was a popular excursion vessel able to navigate through many narrow channels unavailable to larger competitors.

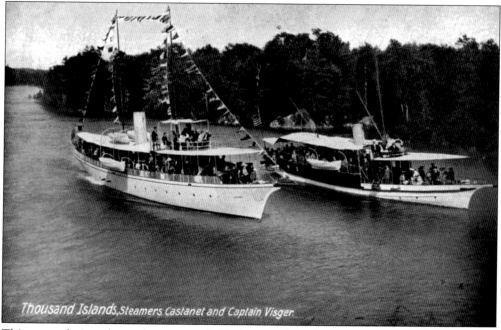

This unusual view shows the *Castanet* (left) along with its fleet mate the *Captain Visger* sailing together toward the International Rift. The sleek steamers were frequently chartered simultaneously for company parties and group outings.

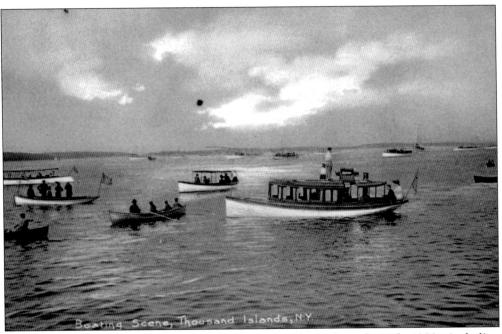

An interesting view of a regatta shows several types of boats from the early 1900s, including steam yachts, motor launches, and rowing skiffs.

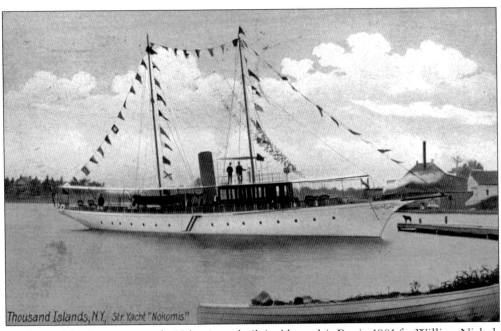

The beautiful private steam yacht *Nokomis* was built in Alexandria Bay in 1901 for William Nichols of New York City and Howe Island, Ontario. She is shown pulling away from the Upper James Street dock in the Bay, with the Abraham and Straus cottages on Cherry Island off the stern.

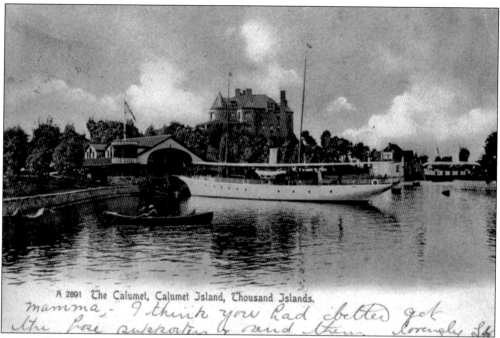

A 2891 The Calumet, Calumet Island, Thousand Islands.

*mamma,- I think you had better get the hose asbestos & send them. lovingly Sk*

Another handsome steam yacht was the *Calumet*, owned by Charles G. Emery of New York City and Calumet Island across from Clayton. In this view, the *Calumet* is moored in the harbor on the north side of the island, with Emery's castle behind.

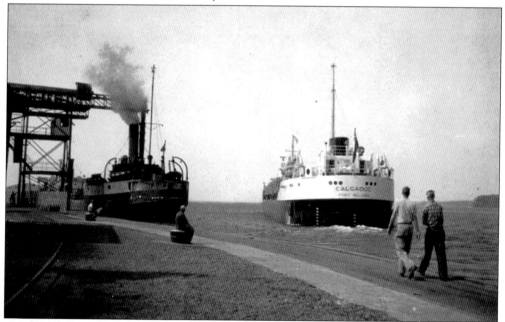

Passenger train service to Clayton was dwindling by the 1950s and with it went the steamship connections to the islands. The coal dock at today's Frink Park was used by commercial ships well into the 1960s when diesel engines and larger ships on the new St. Lawrence Seaway put it out of business. Here two pre-seaway canallers have stopped to fuel up for their trip west onto Lake Ontario.

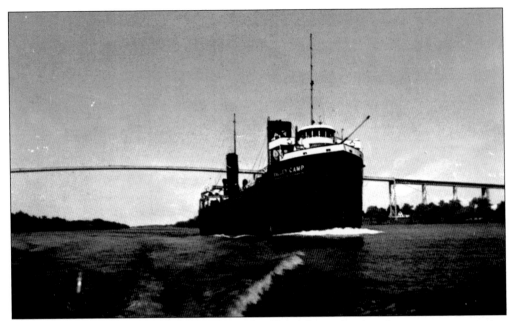

The steam-powered collier *Valley Camp* was a familiar sight on the river for many years, moving coal from Lake Ontario ports downriver to Prescott at the head of the rapids. Too large for the old St. Lawrence canals, she transferred her cargo to smaller canallers for the run down to Montreal.

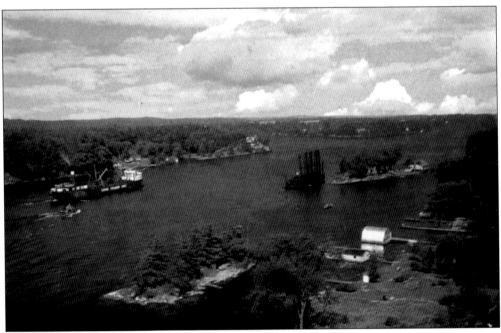

In a 1957 photograph taken looking downriver from the American span, a CSL canaller passes a drilling barge working to widen the channel at Holiday Island for the soon-to-be-opened seaway. In the Thousand Islands section, work was limited to the removal of dozens of rock shoals and the widening of the channel, thus sparing the area from significant changes.

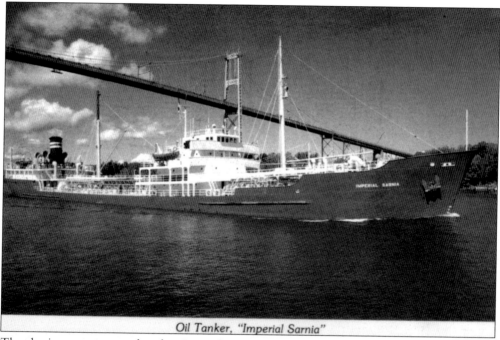

Oil Tanker, "Imperial Sarnia"

The classic steam-powered tanker *Imperial Sarnia* plied the river for decades delivering gasoline and fuel oil to communities of all sizes. She is shown heading downriver under the American span in the early 1960s.

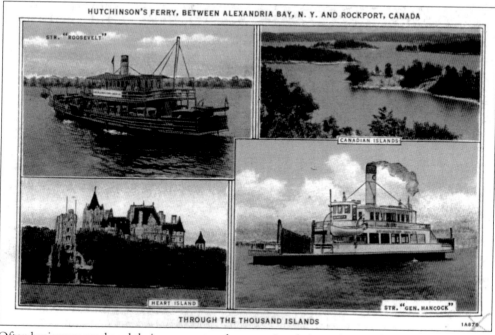

HUTCHINSON'S FERRY, BETWEEN ALEXANDRIA BAY, N. Y. AND ROCKPORT, CANADA

STR. "ROOSEVELT"

CANADIAN ISLANDS

HEART ISLAND

STR. "GEN. HANCOCK"

THROUGH THE THOUSAND ISLANDS

Often businesses produced their own postcards promoting their services, as does this card depicting the two ferryboats that operated between Alexandria Bay and Rockport. No amount of advertising could save the pair from doom when the Thousand Islands Bridge opened in 1938.

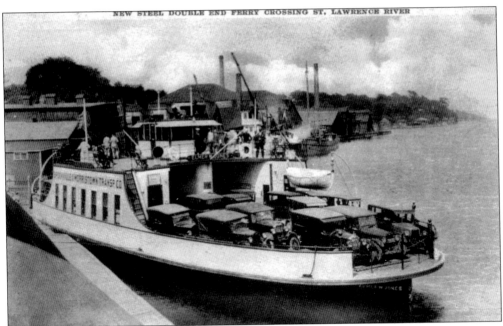

A deck load of 1920s vintage automobiles fills the double-ended ferry *Elmer Jones*, which crossed the river between Morristown, New York, and Brockville, Ontario, until she was put out of business by *two* bridges. The ferry's route was nearly midway between the Thousand Islands Bridge and the Ogdensburg-Prescott International Bridge.

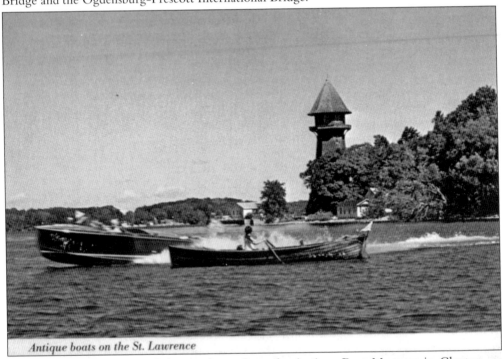

*Antique boats on the St. Lawrence*

Two very different types of pleasure boats from the Antique Boat Museum in Clayton—a St. Lawrence skiff and a mahogany runabout—share the water off Calumet Island's distinctive water tower.

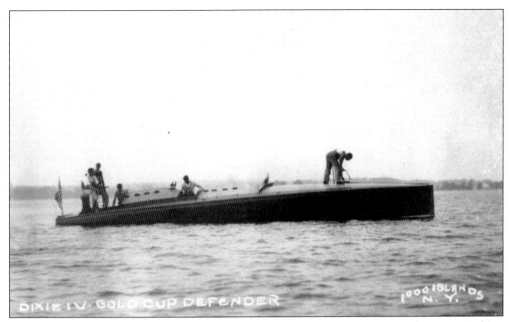

This photograph, taken around 1900, shows the *Dixie IV*, a high-speed Gold Cup race boat similar to several others now in the collection at the Antique Boat Museum. Every other year in mid-August, the museum hosts the Race Boat Regatta featuring classic speedboats like the *Dixie IV*.

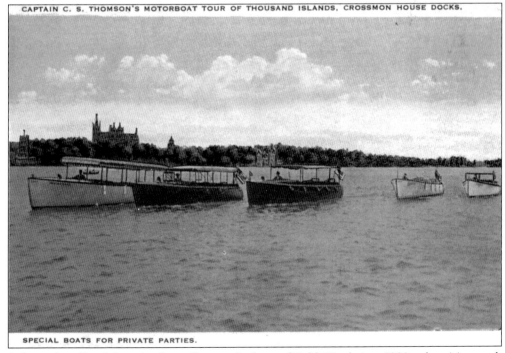

A fleet of smaller sightseeing boats lines up in front of Boldt Castle in a 1920s advertising card.

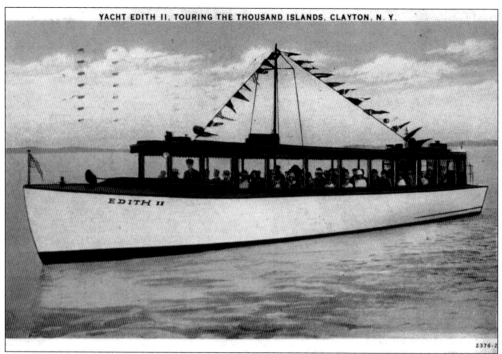

EDITH II

2376-2

The *Edith II* operated out of Clayton and was typical of the narrow, 40- to 50-passenger tour boats that ran trips through the islands for decades.

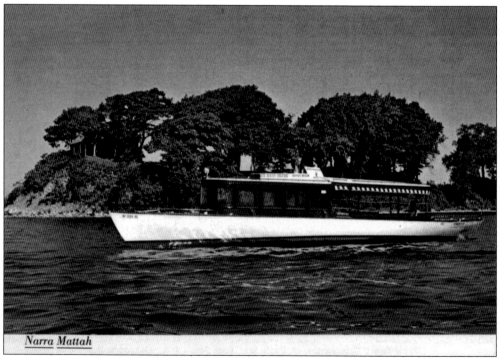

*Narra Mattah*

The *Narra Mattah* was owned and operated by the Antique Boat Museum for many years until the 1990s. She was a 1902 launch built by the Electric Launch Company (Elco).

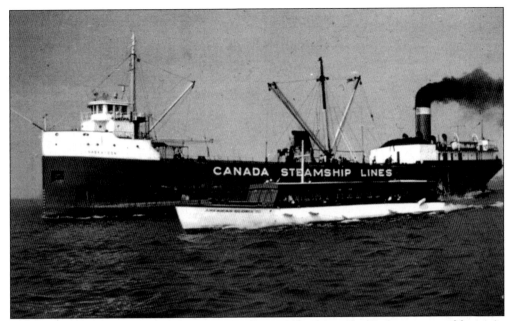

The Clayton-based *American Gloria III* races the coal-fired canaller *Saskatoon* toward home in this late-1940s color card.

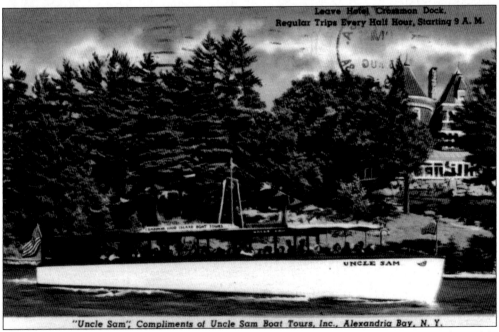

Uncle Sam Boat Tours has operated continuously since the 1920s from its base in Alexandria Bay. Large steel tour boats began replacing smaller wood-hulled vessels in the 1970s.

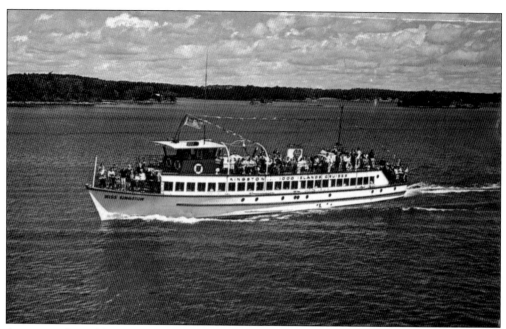

A converted World War II subchaser, the distinctive *Miss Kingston* provided daily tours through the islands into the 1970s.

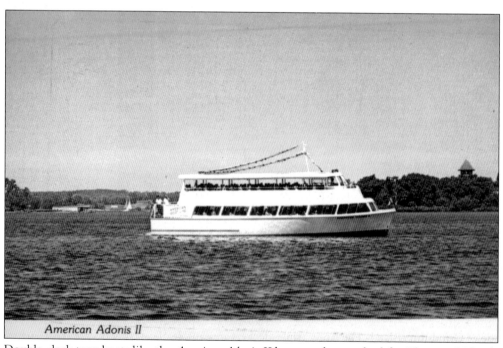

American Adonis II

Double-deck tour boats like the *American Adonis II* became the standard for Thousand Islands tour boats beginning in the mid-1960s.

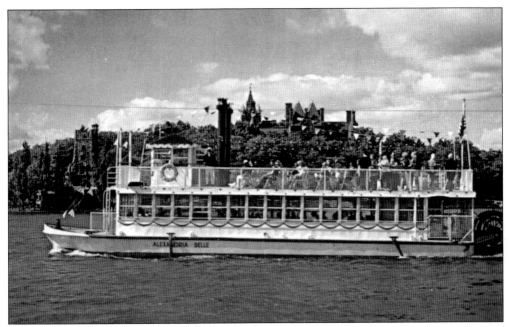

The *Alexandria Belle*, complete with a faux paddle wheel attached to her stern, has carried tens of thousands of tourists on two- and three-hour cruises through the islands since she was launched in the 1970s.

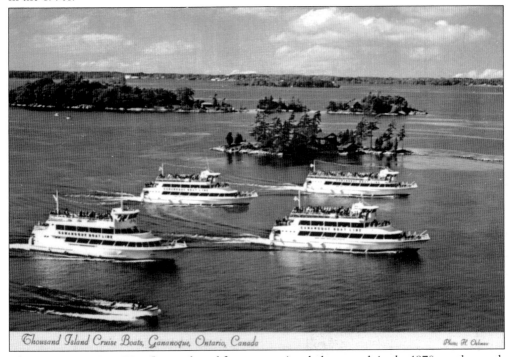

Thousand Island Cruise Boats, Gananoque, Ontario, Canada                    Photo; H. Oehmer

The Gananoque Boat Line fleet gathered for a promotional photograph in the 1970s on the north side of Grindstone Island. The larger triple-deckers are capable of carrying over 300 passengers on scheduled tours through the islands. They are about the same size and capacity of their predecessor steamships from the Gilded Age decades earlier.

ACROSS AMERICA, PEOPLE ARE DISCOVERING
SOMETHING WONDERFUL. *THEIR HERITAGE.*

Arcadia Publishing is the leading local history publisher in the United States. With more than 3,000 titles in print and hundreds of new titles released every year, Arcadia has extensive specialized experience chronicling the history of communities and celebrating America's hidden stories, bringing to life the people, places, and events from the past. To discover the history of other communities across the nation, please visit:

# www.arcadiapublishing.com

Customized search tools allow you to find regional history books about the town where you grew up, the cities where your friends and family live, the town where your parents met, or even that retirement spot you've been dreaming about.